WATERCOLOR TECHNIQUES
PAINTING LIGHT & COLOR IN LANDSCAPES & CITYSCAPES

MICHAEL REARDON

NORTH LIGHT BOOKS
CINCINNATI, OHIO
www.ArtistsNetwork.com

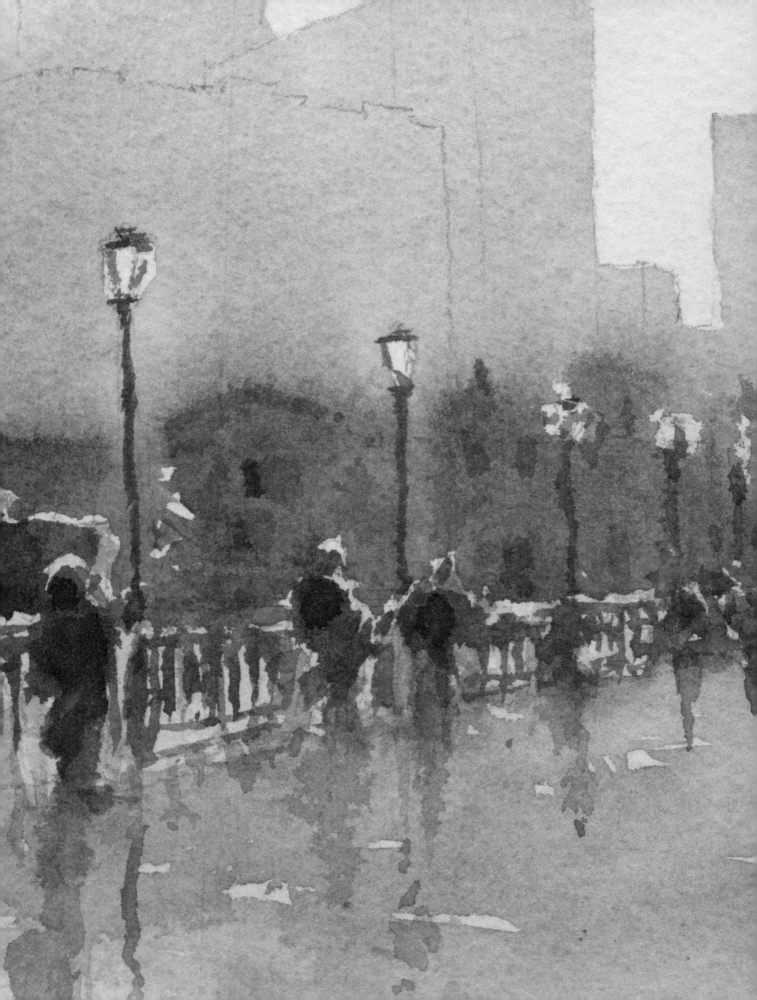

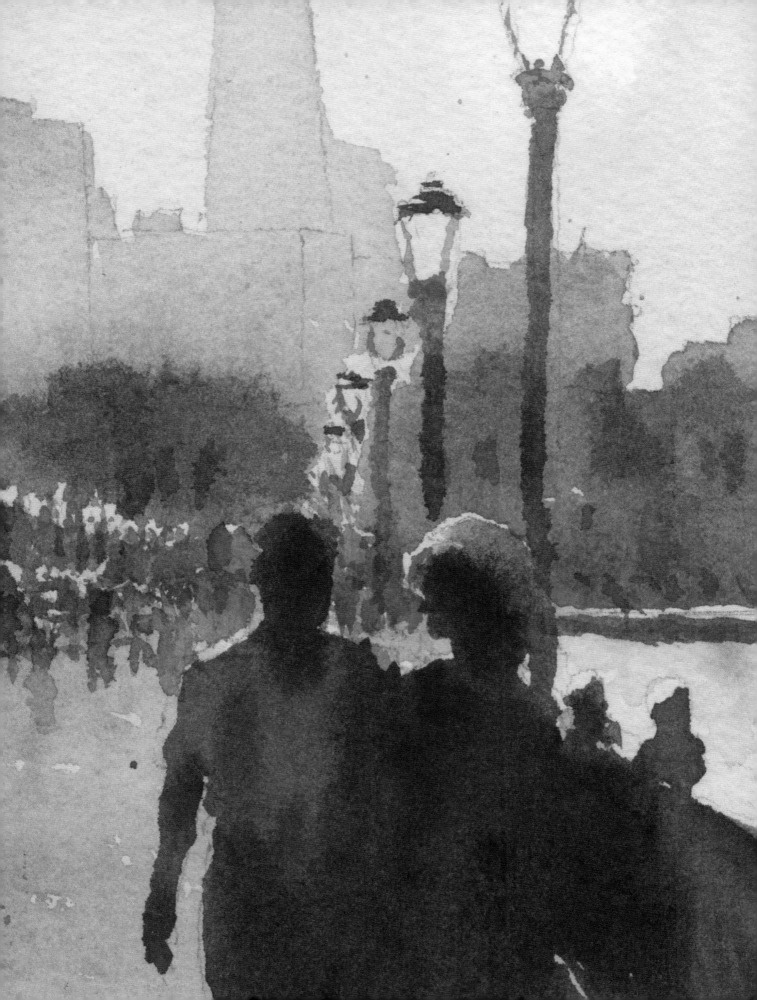

CONTENTS

For bonus content, please visit:
ArtistsNetwork.com/painting-light-and-color.

▷
MISSION DOLORES, SAN FRANCISCO (RIGHT)
Cropped; see Chapter 4 for the uncropped version.

PIER 7, SAN FRANCISCO (PREVIOUS PAGE)
Cropped; see Chapter 6 for the uncropped version.

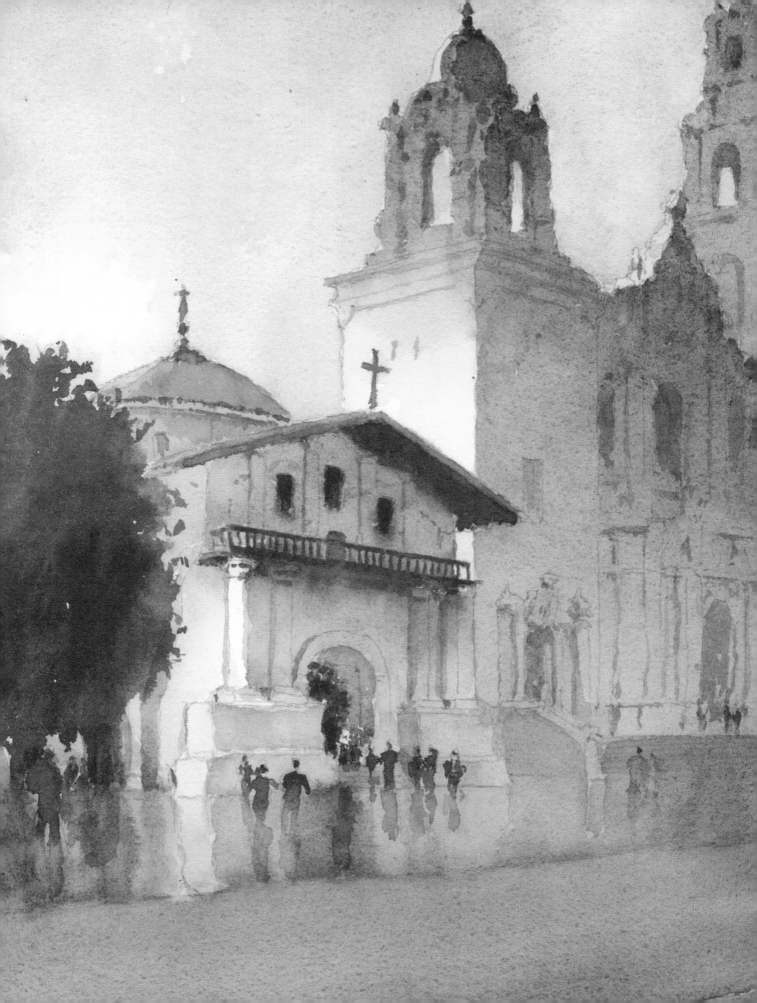

INTRODUCTION

Watercolor can be a struggle. I can relate to these hardships, knowing firsthand how challenging watercolor can be. My introduction to watercolor, during a college survey course in the dry heat of Southern California, was disastrous. The use of cheap brushes, paper and paint—plus my inexperience—resulted in streaked washes, splotchy brushstrokes and depressing results. I was so frustrated and intimidated that I didn't touch watercolor again for ten years.

An exhibit of John Singer Sargent's Venetian watercolors changed everything. I was so completely mesmerized by the beauty of his paintings that I decided I had to try watercolor again. I took a few lessons, joined a plein air painting group and read many watercolor instruction books. Painting whenever I could, I ever so slowly overcame my fear and began to truly enjoy painting in watercolor.

Aside from Sargent, I am indebted to many exceptional artists who have inspired and encouraged me. There are too many to mention here, but I would like to single out two that have a direct influence on a couple of the concepts presented in this book. Jeanne Dobie, the author of *Making Color Sing*, taught me to paint greens. My use of Phthalo Green and Viridian derives from a workshop I took with her. Joseph Zbukvic, in his book *Mastering Atmosphere and Mood in Watercolor*, introduced me to an ingenious way to explain the pigment-to-water ratio. I have altered his analogies, but the concept belongs to him.

The overriding theme of my artwork is the interaction between architecture and nature. I am ceaselessly fascinated by the interplay of architectural subjects in their natural milieu, be it city or countryside. In this book, I tap into my architectural background to give you tips, tricks and ideas for how to imbue your architectural watercolors with light and color.

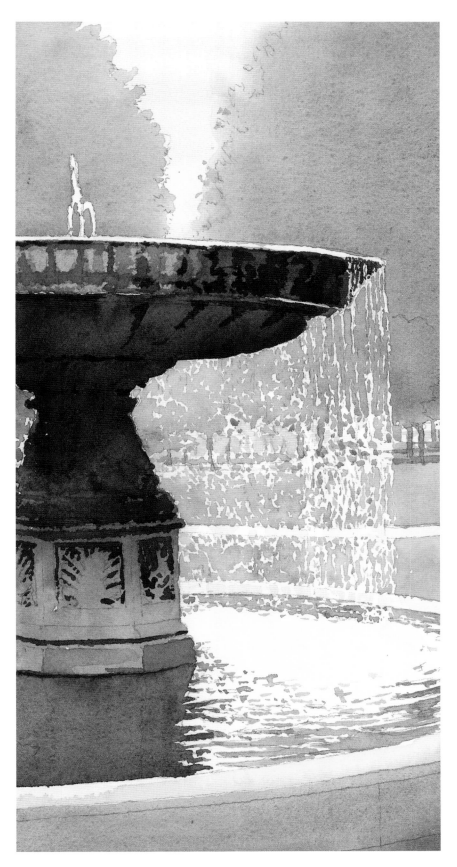

FONTAINE CHAMPS-ELYSÉES, PARIS
13" × 7" (33cm × 18cm)

In 2005, I had the good fortune to spend three months painting in Paris. As the recipient of the Gabriel Prize from the Western European Architecture Foundation, I did a visual study of the public fountains of Paris, all in watercolor. This opportunity to paint every day crystallized my understanding of watercolor. Without any commercial constraints, I was able to experiment and refine my techniques. In this book I share much of what I learned.

Nonstop painting allows you to gain knowledge from both triumphs and disappointments, and is the best way to master watercolor. While a failure teaches you what not to do, the pleasure of success spurs you on. Gradually, painting with this often unforgiving medium becomes pure enjoyment.

WHAT YOU NEED TO KNOW

When I was learning watercolor, I had many questions. Which paper, brushes and pigments do I use? How do I do an even wash? What is wet-in-wet? How do you stretch paper? Why do my paintings look so washed out? Learning watercolor technique and determining which materials work best was daunting. Answers to some vexing problems are covered in this book.

Yet methods and materials alone don't make a masterful architectural painting. Understanding the power of perspective, values and color is essential. Perspective provides the basic framework. The deft arrangement of values is the road map to composition. The effect of color on the mood and feeling of a painting captivates the viewer. Your paintings will benefit from a deep understanding of this trifecta.

Ultimately you will discover your own style of painting. After gaining a comfort level with watercolor painting, you can begin to develop your own approach. There are many demonstrations of my paintings in this book. Study them closely and follow the steps. Then, being mindful of the concepts of value and color, find the materials and techniques that work for you. Persistence and practice will eventually generate light and atmosphere in your landscape painting.

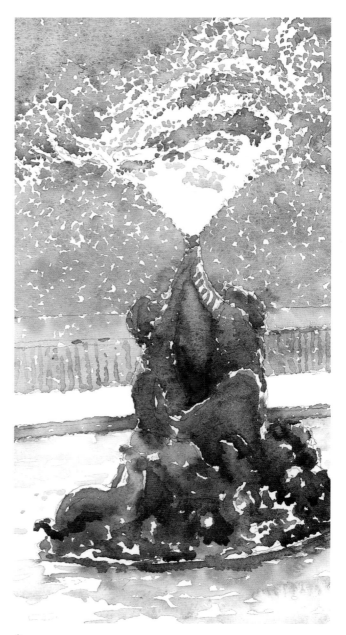

BASSIN SOUFFLOT, PARIS
9" × 5" (23cm × 13cm)
The joy of watercolor is often forgotten when learning to paint. Because the medium can be so hard to control, frustration can often be overwhelming. Watercolor has a mind of its own which must be respected. Even veteran painters experience washes and strokes that go awry. Yet when the paint flows and yields harmonious and satisfying paintings, there are few things quite as pleasurable.

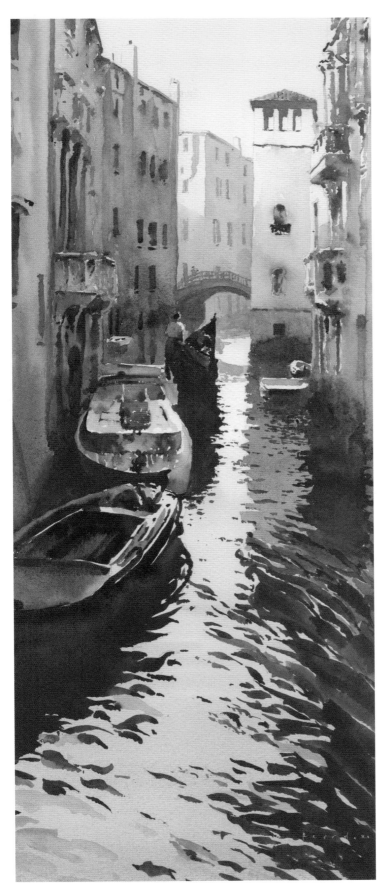

CANALE, VENICE
25" × 10" (63cm × 25cm)

Over the years I have had the opportunity to visit Venice many times. The quality of light and the striking architectural beauty provides ample subject matter for a watercolorist. It's no wonder that John Singer Sargent often painted there. This painting demonstrates one of the main themes in this book: the use of values and color to evoke a sense of light and mood. As their values shift, the buildings recede in misty softness, while the colors of early morning light conjure a feeling of quietude. Values and color work together to both illuminate and create atmosphere in your watercolors.

◆

Watercolor painting is a lifelong journey. There are always new and rewarding challenges just around the corner.

◆

1

SETTING UP: GETTING TO KNOW YOUR MATERIALS

◆

Because of my own disastrous first experience with watercolor, I feel it is important to use good quality materials. Since they can be costly, there is a temptation to scrimp and purchase inexpensive tools. This is what I did when I started, and take it from me: Good materials are worth every penny.

In this chapter we will review types of paint, palettes, brushes and paper, and the best ways to set up your painting area, both indoors and out.

RONDA
Detail

PAINTS AND PALETTES

Going to the watercolor section of an art store is like going into a candy store. All of those colors look so delectable. Given the cost of good quality paint, which ones should you buy?

Owning a large number of colors isn't necessary. With just the three primaries—red, yellow and blue—a vast array of colors can be mixed. In fact, a limited palette often leads to harmonious color compositions.

Professional quality paint is preferable to student grade. The main difference between the two is that student grade has more filler and less pigment per tube. A tube of professional grade will last much longer since it has more pigment in the tube.

My palette comprises pure pigment colors, meaning I don't use any pre-mixed colors. All the paints I use are single pigment colors. Many colors you'll find at the store are mixtures of two or more pigments. Most manufacturers list the pigments on the tube, so you can tell if a specific color is pre-mixed.

The chief advantage to using pure pigments is the ability to personally create vibrant color mixes. Beware of mixing too many colors. There is a rule of thumb says mixing more than three pigments can lead to flat, muddy colors. When using pre-mixed colors, each tube already has two pigments. Add one more and you are up to three. Using pure pigments allows you the freedom to develop your own mixtures and helps you maintain a fresh and lively painting.

HERE IS MY PALETTE WITH FIFTEEN COLORS ARRANGED AS I USE THEM.

Note how the cool colors, the blues and greens, are separated from the warm colors, the yellows, reds and oranges. Observe also how the hues are clustered, the blues, greens, reds, oranges and yellows are side by side.

The empty wells are for specialty or experimental colors. Some of my favorites are Phthalo Blue, New Gamboge, Cobalt Violet and Neutral Tint.

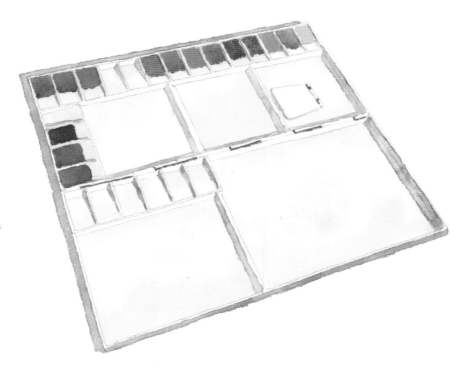

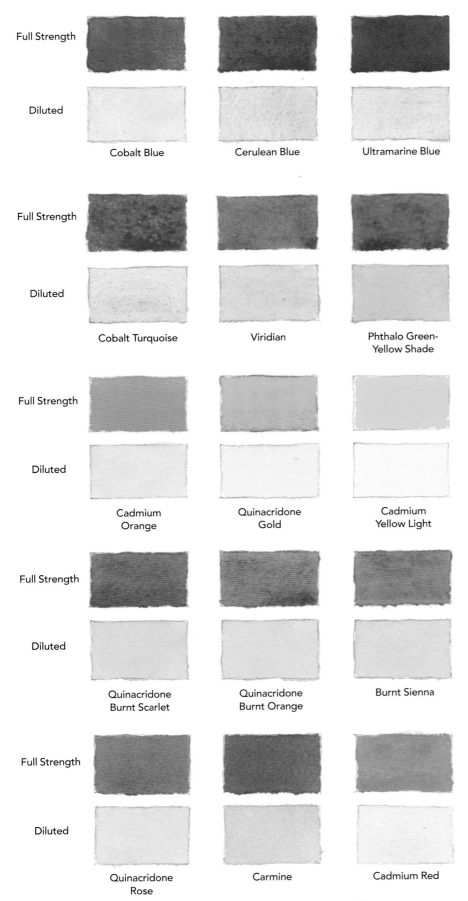

Full Strength

Diluted

Cobalt Blue Cerulean Blue Ultramarine Blue

Full Strength

Diluted

Cobalt Turquoise Viridian Phthalo Green-
Yellow Shade

Full Strength

Diluted

Cadmium Quinacridone Cadmium
Orange Gold Yellow Light

Full Strength

Diluted

Quinacridone Quinacridone Burnt Sienna
Burnt Scarlet Burnt Orange

Full Strength

Diluted

Quinacridone Carmine Cadmium Red
Rose

This color chart shows my go[...] colors. I use these fifteen co[...] ninety percent of the time. I have[...] thoroughly learned the qualities of these colors, so I can paint intuitively, without wasting time choosing colors. This is one of the main reasons that I encourage you to limit your palette. Through practice and experience you will gain a thorough knowledge of the idiosyncrasies of your pigments. The fewer the pigments, the easier it is to know them well.

This chart also demonstrates how the values of pigments change with the amount of water used. For each color, the top rectangle shows the pigment at full strength, with little water added. The bottom rectangle depicts the same pigment diluted with a lot of water. When I was learning watercolor I made a chart like this and kept it on my bulletin board for years. I referred to it frequently until I fully understood my pigments at full strength, diluted, and every value in between.

Over time you will develop your own palette of go-to colors, those that work best for you. In Chapter 2, we discuss pigments in more detail.

BRUSHES AND PAPER

BRUSHES

You don't have to own a lot of brushes. A couple—one large and one small—will usually suffice as long as they have a sharp point or edge.

Watercolor brushes generally come in three categories: natural sable or squirrel hair, synthetic, and blends of natural hair and synthetic. Sables and squirrel mops hold more pigment and water than synthetic brushes. However, synthetic brushes are constantly improving and many brands now approach the quality of sable. They are also less expensive.

Brushes are configured in different shapes: rounds, flats, riggers and so on. I have always used rounds because they suit my painting style. There is no "right" type, just the best one for your style and comfort.

PAPER

Watercolor paper is available in three surfaces: hot press, cold press and rough. Hot press has a plate surface while cold press and rough have more tooth, which makes it easier to create smooth washes. Paper also comes in different thicknesses: 90-lb., 140-lb. and 300-lb. are most commonly used.

Buying large sheets is the most economical way to buy paper. A typical sheet is 22" × 30" (56cm × 76cm). You can cut a sheet into half sheets, quarter sheets, eighth sheets or any size you choose. For travel, watercolor blocks can be handy. Blocks usually contain 20–25 pre-stretched sheets of paper.

I almost always use Arches 140-lb. cold-press paper. It can stand up to heavy washes and is very durable. Different brands have slightly different surfaces. It is worth experimenting with different papers to see what most appeals to you. Eventually you will find a paper that best suits your style.

◆

The choice of brushes and paper is very personal. Using the best brushes and paper you can afford will make your painting experience more enjoyable.

◆

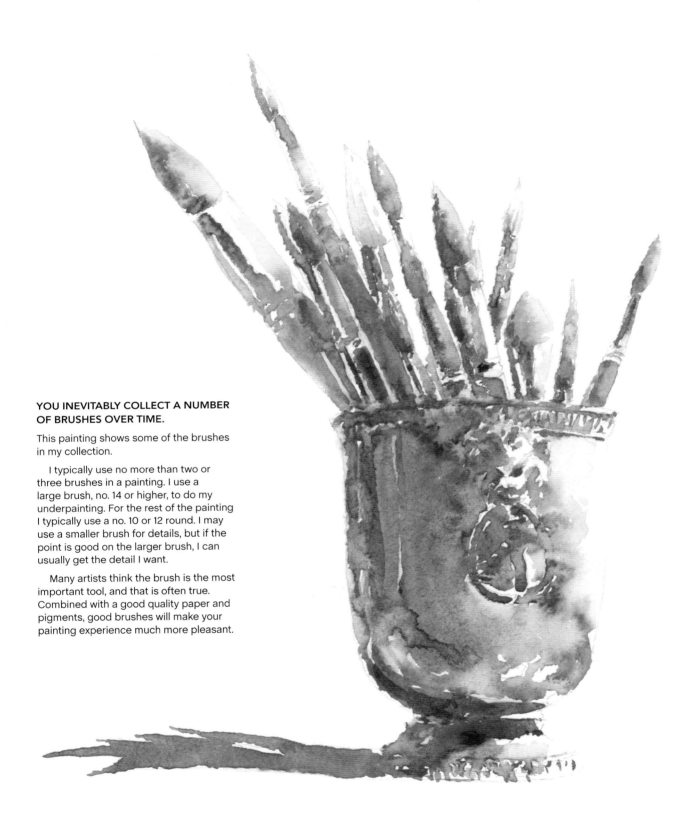

YOU INEVITABLY COLLECT A NUMBER OF BRUSHES OVER TIME.

This painting shows some of the brushes in my collection.

I typically use no more than two or three brushes in a painting. I use a large brush, no. 14 or higher, to do my underpainting. For the rest of the painting I typically use a no. 10 or 12 round. I may use a smaller brush for details, but if the point is good on the larger brush, I can usually get the detail I want.

Many artists think the brush is the most important tool, and that is often true. Combined with a good quality paper and pigments, good brushes will make your painting experience much more pleasant.

A FEW MORE TOOLS

EASEL

Unlike oil painting, an easel isn't essential for watercolor. In the studio you can tape or staple paper to a board and prop it up on your table. When painting outdoors, you can use watercolor blocks or paper taped to a light board. I do use an easel most of the time, but when traveling I limit my weight by using blocks or taping loose sheets to a lightweight board.

SKETCHBOOK AND PENCIL

I recommend a soft pencil, like a 2B, and a sketch-book with paper that has a lot of tooth. A clutch pencil eliminates the need for sharpening.

TAPE, STAPLES AND BOARD

For a half sheet of watercolor paper or smaller, you can use a good quality masking tape to affix your dry paper to a board. This board should be solid cardboard, foam core or light wood. For larger sizes, I find it best to stretch the paper and staple it to a board. To stretch paper, run it under your bathtub tap for a minute or so, lay it on the board, wait five minutes, and staple the paper every 4"– 6" (10–15cm). You must then let the paper dry completely, usually overnight. Stretched paper will stay flat throughout the painting process.

SPONGES AND ERASERS

Use either of these very sparingly because they can damage the paper.

Contrary to popular belief, you can change watercolors with a damp sponge. A damp sponge will lift all or most of the paint from your paper. The downside is that the tooth of the paper can be damaged, resulting in splotchy paint applications.

To remove pencil lines, use a soft eraser such as a kneaded eraser. I use an eraser only after the painting is finished. If you use it prior to painting, you can damage the surface and leave a slight film on the paper, again, leading to splotchy washes.

About the materials lists in this book:
Let's assume you will have at the ready appropriate paper, a selection of your favorite brushes, an easel, tape, a palette, paper towels and anything else essential for the comfort of your painting experience. For each demonstration, I will list only the specific paint colors I used to create the painting.

GETTING COMFORTABLE

My painting setups in my studio and for plein air are not very different. In the studio, since I'm left-handed, I position a table to the left side of my easel (if you're right-handed, position the table on the right). On the table are my palette, brushes, study sketch, paper towels and two water containers. I use one water container for warm colors and the other for cool colors.

My easel is tilted at roughly a 45-degree angle. Depending on your experience, you might find a shallower tilt is easier to control. Keeping your board at an angle allows for even and flowing washes.

When painting outside, I do much the same as I would when painting indoors, but I have a table attached to my easel that accommodates my palette, brushes and water. On the ground are the paper towels, a container that holds extra tubes of paint and my sketchbook.

The chief difference between studio and outdoor work is that you have to carry all of your materials to your location when painting en plein air. For this reason it's important to bring only the necessities and to keep it light. I use a lightweight tripod easel when an easel is useful. Even lighter, a watercolor block or paper taped to a lightweight board eliminates the need for an easel and can be held in one hand while painting. This economy allows me to fit everything into a small backpack when traveling.

STUDIO SETUP

EASEL SETUP

NO EASEL SETUP

CAPILEIRA, SPAIN

PALETTE

+ Cobalt Blue
+ Cadmium Orange
+ Quinacridone Gold
+ Viridian
+ Quinacridone Burnt Scarlet
+ Phthalo Green
+ Ultramarine Blue
+ Burnt Sienna
+ Quinacridone Rose
+ Quinacridone Burnt Orange

1 THE VALUE STUDY

Complete a small value study in pencil, no bigger than 6" (15cm) tall. This study helps to determine composition and values.

2 THE LINE DRAWING AND UNDERPAINTING

Using the value study as a guide, do a line drawing on the watercolor paper. Then, after taping the paper to a board, complete an underpainting. Using two colors, Cobalt Blue and Cadmium Orange, paint the entire surface of the paper, starting at the top and leaving the white on the chapel as unpainted paper. Wash a hint of Quinacridone Gold into the base of the building to create a glow.

Let it dry completely.

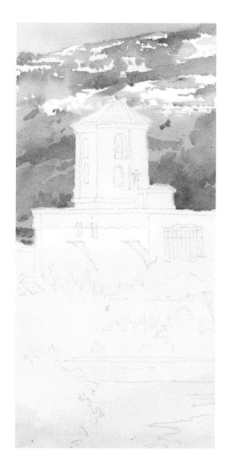

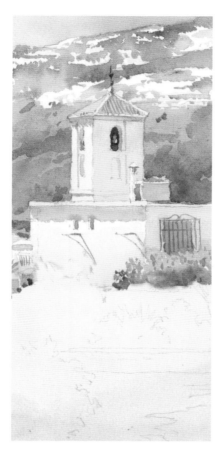

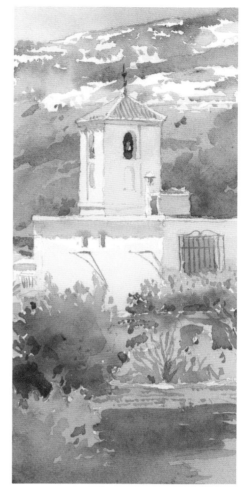

3 THE BACKGROUND WASH

Starting at the top, paint the sky with Cobalt Blue.

When the sky is almost dry, paint the background ridge and trees. Using light washes of Viridian, Cobalt Blue and Quinacridone Burnt Scarlet, suggest the distant trees, allowing the colors to flow into each other.

As you approach the closer trees, use Phthalo Green instead of Viridian to create slightly darker trees.

4 THE MIDDLE GROUND

When the background wash is almost dry, paint the church. Paint the roof with Cadmium Orange. Paint the body of the building with light washes of Cobalt Blue and Cadmium Orange. The dark accents are a mixture of Ultramarine Blue and Burnt Sienna.

To create a soft edge, paint the flowers on the right before the wash is completely dry. Use a mixture of Cadmium Orange and Quinacridone Rose for the flowers.

5 THE FOREGROUND AND FINAL TOUCHES

Complete the foreground with the same group of colors you used in earlier step. The greens are a mixture of Phthalo Green and various oranges, such as Cadmium Orange, Quinacridone Burnt Orange and Burnt Scarlet. The purple shadows are a mixture of Cobalt Blue and Quinacridone Burnt Scarlet.

When you reach the bottom of the paper, you're finished.

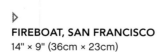

BORGO CORSIGNANO, ITALY
14" × 7" (36cm × 18cm)
The deft use of color can evoke mood and feeling in your paintings.

It isn't necessary to use a lot of colors to achieve a successful painting. Using color sparingly and strategically can help lead the viewer's eye to the focal point of the painting.

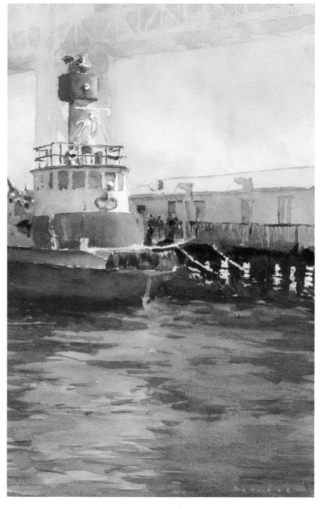

FIREBOAT, SAN FRANCISCO
14" × 9" (36cm × 23cm)
A strong color, such as the red of this fireboat, can create a powerful focal point. This painting was done at San Francisco Bay, with an umbrella attached to my easel to shield the sun. A strong gust of wind knocked over my easel, and one of my squirrel mop brushes tumbled into the bay. Luckily I was able to flag a kayaker, who scooped it up and threw it back to me. The joys of plein air painting.

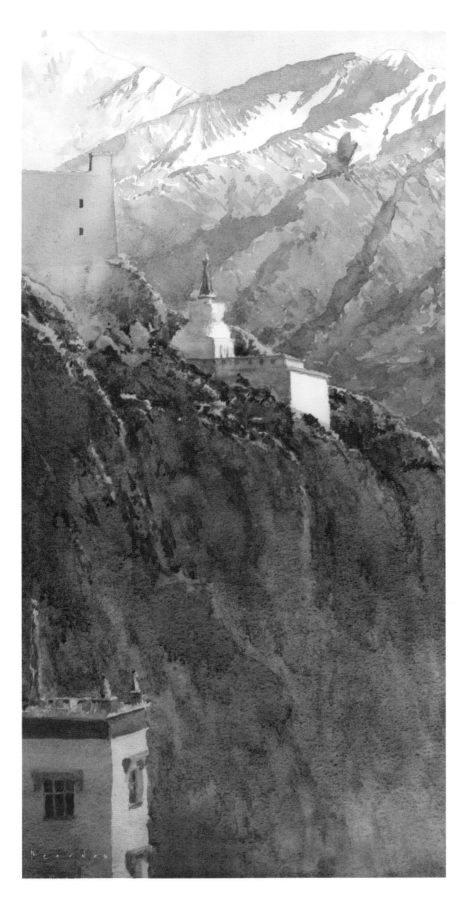

◁
LEH PALACE, LADAKH
20" × 10" (51cm × 25 cm)
It isn't necessary to use every color in
your palette. In this painting, only six
colors were used. Limiting your palette
can help create color harmony.

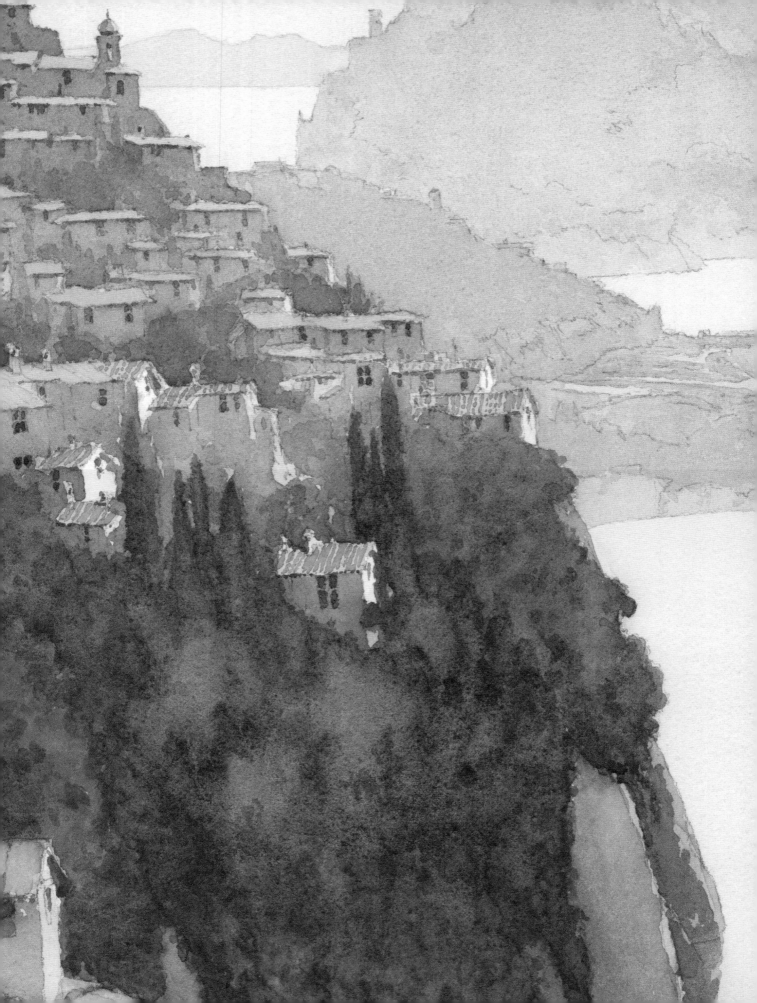

2

THE SECRET WORLD OF PAINTS: UNLOCKING THEIR MYSTERIES

———————◆———————

Not all pigments are created equal. Some are transparent while others are opaque. Some stain, some don't. Some pigments create intense colors; some are light and delicate. Understanding the nature of pigments is essential to the creation of luminous watercolors. In this chapter we unlock some of these valuable secrets.

◁
GARDA
Detail

COLOR CHEMISTRY 101

Fundamentally, paint is composed of ground or synthesized pigments mixed with a filler to give it body, usually gum arabic. This is the mixture in a tube of watercolor paint.

All pigments have unique chemical properties that make them stain paper, sit on top or something in between. Similarly, the chemical makeup determines the transparency or opacity of watercolor pigments.

Knowing when a pigment will stain the paper or easily lift off with a paper towel or sponge is invaluable. Understanding the relative transparency or opacity of a paint is vital when layering washes or painting wet-in-wet.

Many paint manufacturers provide charts that detail some of these characteristics. It is worthwhile studying these. You don't need a master's degree in chemistry, but an intuitive knowledge of the unique properties of pigments will help you to apply paint with confidence.

The essential difference between transparent and opaque paints is the size of the particles in the pigment. Transparent pigments have very fine particles, while opaque paints have very large ones. You can see in the top diagram how Aureolin is very transparent and doesn't cover the black square. In the middle, a semiopaque pigment, Naples Yellow, covers some of the black square. At the bottom, a very opaque pigment, Bismuth Vanadate Yellow, hides much of the black square.

TO STAIN OR NOT TO STAIN

Many people believe watercolor can't be altered once it's down on paper. In fact, many pigments can be wiped away with a sponge, paper towel or brush, a process known as *lifting*. However, some colors stain the paper and can't be lifted.

Here are some of the pigments that stain:

+ Phthalo pigments, such as Blue and Green
+ Carmine
+ Quinacridone pigments, such as Gold, Burnt Orange, Burnt Scarlet and Violet

Many others are partially staining, such as Ultramarine Blue, Perinone Orange and many red pigments.

TRANSPARENT PIGMENTS
Like tea, these pigments are completely translucent.

SEMITRANSPARENT SEMIOPAQUE PIGMENTS
Like lemonade, these pigments are slightly opaque.

OPAQUE PIGMENTS
Like espresso, these pigments are quite opaque.

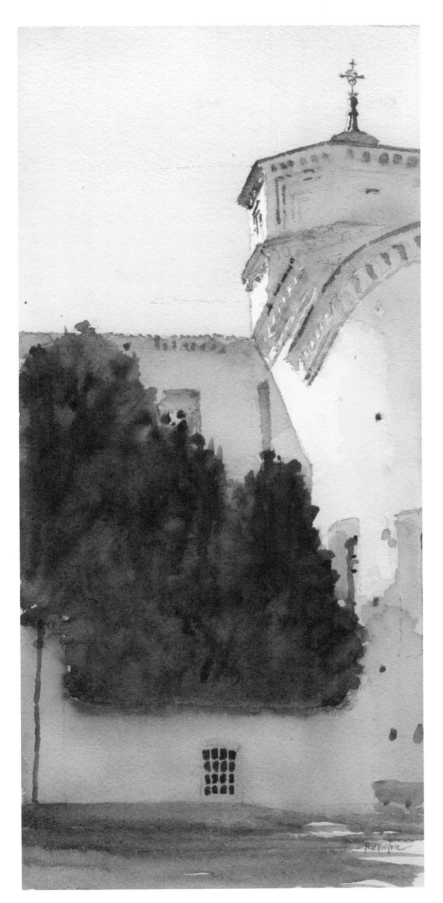

◁
SANTA MARIA IN PORTO, RAVENNA
13" × 6" (33cm × 15cm)
Most watercolors use a combination
of staining and nonstaining colors, as
well as transparent, semitransparent
and opaque paints. In this painting, the
two dominant colors are Cobalt Blue,
a transparent pigment, and Cadmium
Orange, a relatively opaque pigment.
Neither color is a staining pigment. Note
that opaque colors, such as Cadmium
Orange, still have some transparency
when diluted.

THE DARK SIDE

There is no such thing as a dark watercolor pigment. Even black pigments will look pale if they are highly diluted. Unlike pencil, with which repeated passes and bearing down will create a dark mark, watercolor creates darks in unique ways.

First, only certain pigments can be mixed to yield a dark value. Some colors, such as Aureolin, Viridian and Cobalt Blue can never be made dark, no matter how much pigment is applied. They are by nature lighter-valued colors. Colors such as Phthalo Green and Blue, Carmine, Carbazole Violet and Winsor Violet, however, have a much larger value range and can be made dark.

In addition to using the correct pigments, the most critical ingredient for darkness is the pigment-to-water ratio. The secret to making darks is to use a lot of pigment and little water. Even the above-mentioned dark value colors will appear light when mixed with a lot of water. The darkest colors are barely diluted pigments straight from the tube.

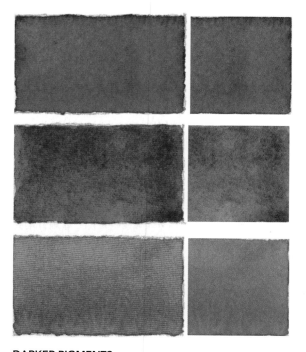

DARKER PIGMENTS

Phthalo Blue

Phthalo Green

Carmine

LIGHTER PIGMENTS

Manganese Blue

Viridian

Cadmium Orange

This is an example of a few colors and their values, the lightness or darkness of each pigment.

Each of these colors has been converted to gray scale so that you can see their darkness or lightness independent of the hue. Clearly the set on the left has darker pigments than the set on the right.

The light pigments, such as those on the right, will never be very dark. By their very nature they are light in value. Even if you applied the pigment straight from the tube, the color would not be dark.

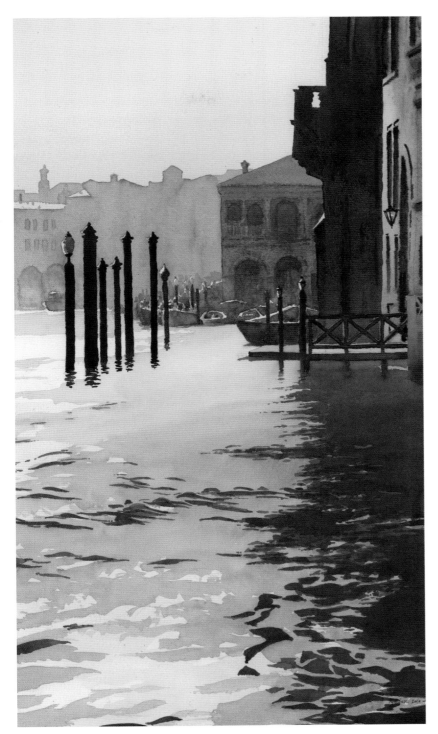

CANALE GRANDE
26" × 14" (66cm × 36cm)
Knowing which pigments have the
potential to be dark or light will help you
to create light-filled paintings. The light is
accentuated by having dark colors next
to it.

In this painting, the sky is Cadmium
Orange and Cobalt Blue, two colors that
will never be dark. Skies are rarely dark.
Keeping this sky light in value imbues the
painting with a warm light.

In contrast, the dark areas are painted
with dark pigments. For example, the
dark green in the water is a mixture
of Phthalo Green, Quinacridone Burnt
Scarlet and Cobalt Turquoise, all colors
that have a darker value range.

Paintings will always have a range of
light and dark colors. It is important to
know which of your pigments will achieve
the effect you are after.

*Many pigments aren't lightfast. Colors such
as Alizarin Crimson and Prussian Blue are
known as fugitive colors; they fade over
time. It is best to use lightfast pigments.
Lightfast ratings are sometimes printed on
the tube or available online.*

LUMINOSITY

What distinguishes watercolor from all other media is its luminosity. Unlike opaque media, such as oil, acrylic or pastel, light passes through the watercolor pigment and bounces back off the white paper. This is why watercolor paintings glow.

To maintain this luminosity, it's important not to overwork watercolor paintings by layering wash over wash. Otherwise, the painting will begin to look dull. These layers make it difficult for the light to pass through.

I normally paint all in one go, putting down the paint once and leaving it alone. No matter how dark and heavy the paint might get, the light will always shine through. This method of painting ensures glowing pigments.

Too many colors mixed together usually results in a muddy and lifeless wash. A rule of thumb says that mixing more than three pigments will usually result in a flat, uninteresting color. But that's not always true. Mixing more than three colors together can work, as long as you know your pigments well. It is safer, though, to limit your color mixtures to three or less. Once you know the properties of your pigments, you will know which pigments work best in multiple mixtures.

Ultimately it is best to let watercolor be watercolor, allowing its transparent luminosity to shine.

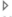

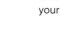

MUSEO NACIONAL, BARCELONA
14" × 9" (36cm × 23cm)
You can ensure transparency in your paintings by not going over your first washes. Getting the color and value you want in one pass will guarantee luminosity. Going over the initial washes, while sometimes necessary and desirable, can also lessen the glow of your painting.

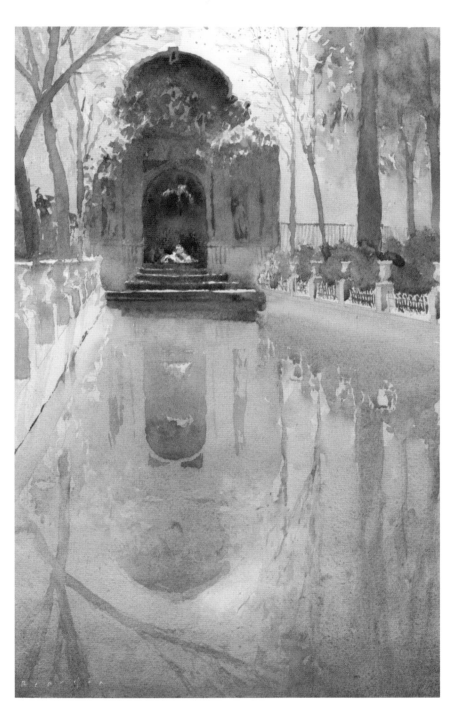

◁

FONTAINE DES MEDIÇIS, PARIS
14" × 9" (36cm × 23cm)
One of my favorite lighting conditions is backlighting. Such lighting creates luminosity by having a bright sky area in contrast to other objects in shade. Shade and shadow areas can also be luminous. Just because they are dark doesn't mean they don't have light shining through them. In this painting, I kept the colors bright and lively, never mixing more than three pigments together.

FONTAINE DES MEDIÇIS, PARIS

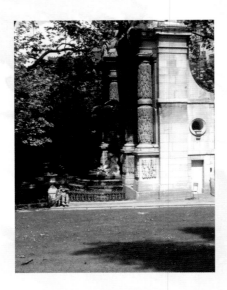

PALETTE

+ Cobalt Blue
+ Cadmium Orange
+ Quinacridone Burnt Scarlet
+ Ultramarine Blue
+ Viridian
+ Cerulean Blue
+ Carmine
+ Phthalo Green
+ Quinacridone Rose

REFERENCE PHOTO

This is one of my favorite fountains in Paris, the Fontaine des Mediçis located in the Luxembourg Gardens. This demonstration shows how to use various pigments to create a strong sense of light.

Note that the photo is printed in black-and-white, which permits a better understanding of the values required for the painting.

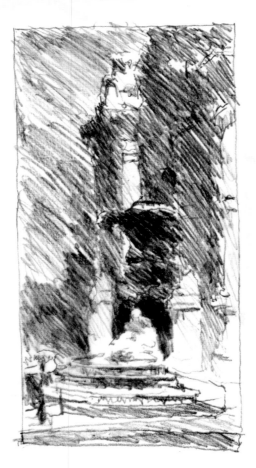

1 THE VALUE STUDY

This value study determines the values of the painting, not the color scheme. Just as with the gray scale reference photo, you don't need to be concerned with colors and pigments. At this stage, you concentrate on the values. If you get the values right, you can put any color down.

This is also the time to determine your focal point. In this case it is in the lower center, the only place where there is black against white.

2 THE UNDERPAINTING

Using Cobalt Blue and Cadmium Orange, apply a wash over the entire paper, leaving the white paper unpainted around the focal point. The wash should be very diluted. Start with the Cobalt Blue at the top (sky area) and use the orange mostly on the fountain and distant trees. Some Cobalt Blue is reintroduced at the bottom. This underpainting establishes all of your light values. Let it dry completely.

3 THE SKY AND BACKGROUND

Beginning at the top, paint the top of the fountain and start the background trees. For the fountain, blend Cobalt Blue, Quinacridone Burnt Scarlet and Ultramarine Blue. The trees are a mixture of Viridian, Quinacridone Burnt Scarlet and Cerulean Blue. Try to mix the colors on the paper, rather than on your palette. This should result in greater translucency and vibrant colors.

4 THE BACKGROUND

Continue with the background, using the same colors as before: Viridian, Quinacridone Burnt Scarlet and Cerulean Blue. You can also add Cobalt Blue.

Cool colors, such as blue, recede, which is appropriate for the background. You can also keep the trees vague and undefined to reinforce the illusion of distance.

Note that the pigments are all light-valued colors, even at full strength, with the exception of Quinacridone Burnt Scarlet. This pigment is highly diluted to attain its light value.

 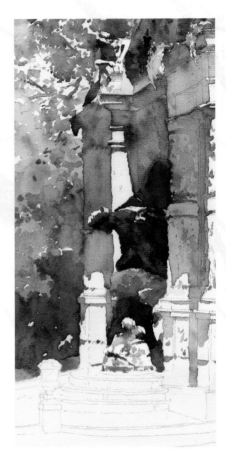

5 THE FOUNTAIN

Once again beginning at the top, paint the fountain using primarily Cobalt Blue, Cadmium Orange and Quinacridone Burnt Scarlet, with a bit of Ultramarine Blue. These pigments are less diluted than the background, resulting in slightly darker values. The very dark arch is a mixture of Carmine and Phthalo Green, painted very heavily with little water added.

6 THE OGRE

To achieve the dark bronze patina of the ogre, use Phthalo Green, Carmine and Ultramarine Blue to paint the very dark areas. These pigments have the capacity to achieve dark colors. In fact, Phthalo Green and Carmine together create black since they combine all three primary colors: blue, yellow and red.

Cobalt Blue and Quinacridone Rose are also added to achieve some of the lighter-valued areas.

Continue with the colors on the monument as in Step 5.

7 THE FOCAL POINT

Paint the very dark area below the ogre to set off the focal point, the lovers Galatea and Acis. It is important to make this area very dark, using the same colors you used for the ogre. The contrast with the white at the top of the statuary will draw the eye to this point.

Using the same colors you used in the monument, paint the lighter areas of the statue.

Finish the background with a mixture of Phthalo Green, Quinacridone Burnt Scarlet and Ultramarine Blue, making a slightly darker area at the bottom of the trees.

DETAIL

This actual-size detail shows how many of the colors are blended wet-in-wet. We cover this technique in the next chapter.

Notice that there aren't any muddy areas. No more than three pigments are mixed into any one area.

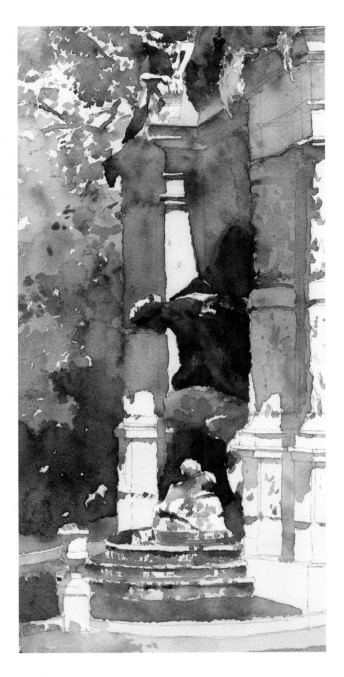

8 FINISHING UP

Continue working down the page, painting the dripping water and pool. For these, use Cadmium Orange, Viridian and Cobalt Blue. You have plenty of license when choosing the colors for the dripping water. What is most important is leaving some white spaces so the water appears to sparkle.

Finally, paint the walkway with Cadmium Orange, continuing it over the lawn. When it is dry, glaze a coat of Viridian over the top. A few tree shadows on the left bottom, using Cobalt Blue and Quinacridone Burnt Scarlet, complete the painting.

Painting in watercolor requires planning ahead. It can take some time, but eventually when you can see in your mind the final result, you will become more confident and assured, and it will show in your paintings.

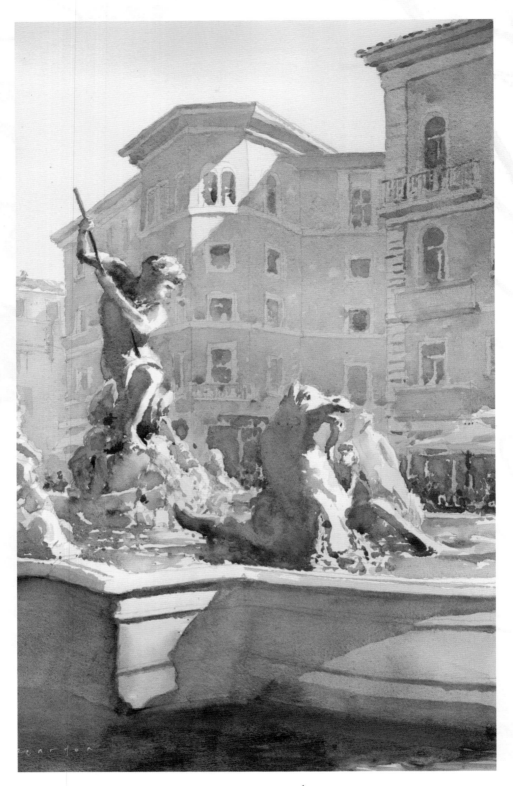

FONTANA NETTUNO, ROME
18" × 11" (46cm × 28cm)
It isn't necessary to use all of the colors in your palette. Many times a limited palette will help to harmonize your painting. Also, fewer colors make it less likely that you will create muddy hues.

POOLSIDE, TURKEY
10" × 5" (25cm × 13cm)
Striving for transparency doesn't mean you can't use opaque colors. Opaque colors are still transparent. It's just a matter of degree.

In this painting I used Cerulean Blue, Cadmium Orange and Cobalt Turquoise, all colors that are considered semi-opaque or opaque. I also used some very transparent colors, such as Cobalt Blue, Phthalo Green and Quinacridone Gold.

Most paintings will have a mixture of transparent and opaque pigments. Knowing how to use them is what counts.

SAN MARCO, VENICE
7" × 5" (18cm × 13cm)
This painting was unfinished when a pigeon dropped a "deposit" on my palette. After a moment of disgust, I agreed with the bird that it was time to stop. The transparency at the bottom leaves more to the imagination and keeps it luminous. Sometimes the critics are right!

3

LAYING IT DOWN: EXPLORING BASIC TECHNIQUES

◆

Unlike opaque media, watercolor is not applied using individual brushstrokes. Watercolor is laid on the paper using washes or by applying the paint wet-in-wet. Often these two techniques are used in tandem.

Washes fall into two categories: flat and gradated. In wet-in-wet painting, you drop wet paint into an already wet area of the paper, allowing the pigments to mingle and mix on the paper.

Other watercolor paint techniques include splattering, scraping and blotting. While these techniques are often useful, the wash and wet-in-wet application are basic and intrinsic to watercolor painting.

CASCADAS
Detail

37

THE MILKY WAY

DAIRY PRODUCTS AND MIXING WATERCOLORS

The ratio between pigment and water is the most critical concept in watercolor. It is this ratio that determines the darkness and lightness of your painting and is essential for doing both flat washes and wet-in-wet painting.

To assist in this understanding, I have developed a set of dairy analogies. If you keep in mind the consistency of each of these dairy products, it will help you to determine the ratio of paint to mix with water and vice versa.

Non-fat milk, for example, is very watery. A similarly mixed paint mixture will be very pale. On the other hand, a mixture like cream, with much more pigment than the non-fat milk, will yield a much darker value of paint.

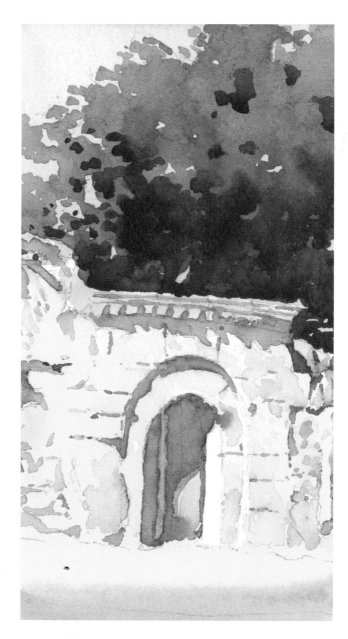

▷
GARDEN DOOR, GOREME, TURKEY
7" × 4" (18cm × 10cm)
This small sketch of an old door in Turkey displays all of the dairy consistencies, from the very pale stone colors to the dark underside of the tree. If you need light values, use the consistency of the lighter dairy products. If you need dark values, use the heavier ones.

NON-FAT MILK

A very watery ratio, with very little pigment and a lot of water.

2% MILK

Still a very watery ratio, but with more pigment than non-fat milk.

WHOLE MILK

This mixture has even more pigment than non-fat and 2% milk.

CREAM

This mixture is indeed creamy, having little water and a lot of pigment.

YOGURT

This is pigment right out of the tube, with perhaps a little bit of water to make it flow.

WASHES

The flat wash is a single color applied uniformly to the paper. It is probably the most basic way to paint watercolors. Many watercolorists build up color using the glazing technique, which is a successive layering of flat washes. While it can take time because each wash must be completely dry before the next is applied, the technique creates glowing areas of color.

In a gradated wash you paint a single color from light to dark or dark to light, or you blend one color into another color. It takes some practice but is very useful, particularly for skies in landscape painting.

FLAT WASHES

THE VENERABLE BEAD

In all washes, keeping a bead of water and pigment moving down the page ensures an even wash. With your paper slanted at a 15-degree angle (or more), start at the top with a horizontal stroke, creating a bead that pools at the lower end of the stroke. Your next stroke captures the bead and moves down a bit more, continuing down the page.

THE FLAT WASH

To create a flat wash, make a pool of one color and wash it down the page. Keeping your bead of water and pigment moving down the page, you draw the single pigment horizontally until it reaches the bottom.

GLAZING

Glazing creates a new color by layering one flat wash over another. In this case, apply a flat wash of Quinacridone Gold. When it is completely dry, lay a flat wash of Viridian over it. Like a sheet of glass, light shines through both layers to create a yellow-green. Any colors can be glazed, but use a more transparent color as the top wash for the best results.

GRADATED WASHES

GRADATED WASHES

A gradated wash is created much in the same way as the flat wash, starting with a lighter wash and transitioning to a darker wash, or vice versa, as you move your bead down the page. Similarly, you can gradate different colors. The third example starts with Cadmium Orange and gradates with Cobalt Blue. In the middle of the wash, you add more water to ensure a smooth transition. Any colors can be used, but transparent colors go down more evenly. (Above, from left to right: light to dark, single color; dark to light, single color; two colors, gradated.)

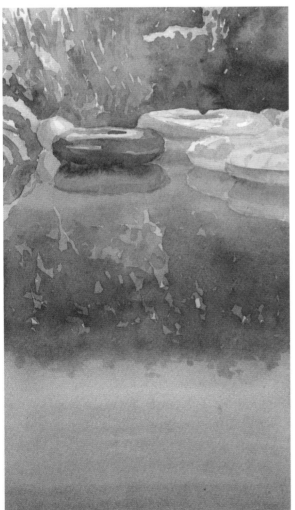

◁
SUMMERTIME IN MAINE
9" × 5" (23cm × 13cm)
In this painting you can see the use of a gradated wash in the water. The pigment changes from blue to bluish green near the bottom. The green reflection is glazed over the blue wash. Much of the rest of the painting is wet-in-wet, which is discussed on the next pages.

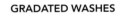

PAINTING WET-IN-WET

Wet-in-wet painting is unique to watercolor. Laying wet paint into a wet surface can create effects only accomplished in watercolor. Pigments mingle with other pigments and create lively mixtures as they dry.

The dairy mixture analogies are critical to wet-in-wet painting. Timing the introduction of a wet wash onto wet paper takes some practice, but it can yield spectacular results. As a rule, you first lay down more watery washes (non-fat and 2% milk) and then drop in the same weight or heavier washes into the mixture. If you go the other way around, you risk getting unsightly blooms that are difficult to remove.

Timing the moisture in the paper is also very important. While the paper is quite moist, you can work the area for a fairly long time. It is at this point that wet-in-wet works best. Once the area is dry, it is time to stop. If you fail to stop at this point, you risk losing the freshness and luminosity of watercolor.

▷
THE ESTUARY
14" × 9" (36cm × 23cm)
Most of this painting was done with the wet-in-wet technique. The sky is a mélange of Cadmium Orange and Cobalt Blue. The cranes are Cobalt Blue, Quinacridone Burnt Scarlet and Ultramarine Blue mixed together on the paper while the paper was moist. Similarly, the dark foreground is a mixture of the above colors plus Phthalo Green and Carmine. The fresh quality of the paint remained by not repainting the areas after they dried.

WET-IN-WET PROCESS

You can continue this process with any colors you wish as long as the wash stays moist. It's best to lay heavier washes into lighter washes. Once you reach the value and look you are after, let the paint and paper dry completely. Remember, the wash will dry much lighter than it looks when wet, so you have to make it darker than you think necessary.

In wet-in-wet painting you can use your paper as your palette, laying and mixing the colors on the paper to get the correct hue and value. This technique yields very interesting color mixtures.

Once a wet-in-wet wash has dried, it is best to not paint over it. Though you may be tempted to do so since washes dry so much lighter than they appear when wet. But painting over a wet-in-wet wash results in a loss of luminosity and will cause a flat look. Getting the value right the first time is the best way to go, but it does require a bit of practice.

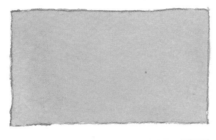

1 Using a 2% milk–consistency wash of Quinacridone Burnt Scarlet, paint the entire rectangular area.

2 While the wash is still moist, lay in a whole milk–consistency wash of Viridian over part of the area.

3 While this wash is still moist, lay in a whole milk–consistency wash of Cerulean Blue into part of the area.

Humidity and temperature are very important in painting wet-in-wet. If it is too hot and dry, mixing colors before they dry can be problematic. There is a reason the British make watercolors and the Navajo make sand paintings.

A FEW MORE TECHNIQUES

In addition to flat washes and wet-in-wet, there are a few other ways to apply paint to paper. From splattering the paint to dry brush, these techniques aren't frequently used, but they can complement the more traditional ways of applying paint.

SPLATTERING ON WET PAPER

By flicking a loaded brush or toothbrush, splatter paint on a wet surface.

SPLATTERING ON DRY PAPER

Same as above, only using dry paper.

DRYBRUSH

Using a dry brush loaded with a heavy paint mixture, drag the brush across the paper.

BLOTTING

Blot out some of the paint while the wash is still moist, using a paper towel or a soft cloth rag.

MASKING

Mask areas using masking tape or masking fluid to preserve the white of the paper. I use drafting tape that doesn't damage the paper. Other ways to revive the white of the paper include a damp sponge and scraping the paper with a razor blade.

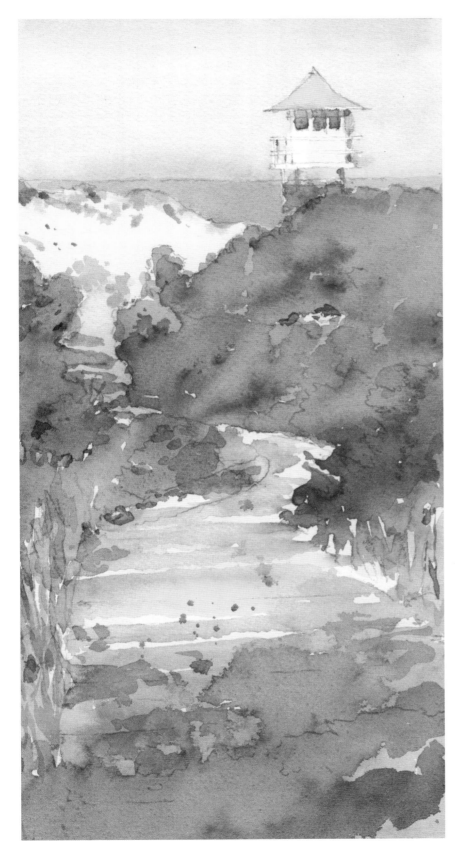

△
FONTAINE DES MERS, PARIS
11" × 7" (28cm × 18cm)

◁
COURAN COVE, AUSTRALIA
11" × 5" (28cm × 13cm)

In both of these examples you can see the use of splattering to evoke the spray of water or roughness of a trail.

THE SEINE AT SUNSET, PARIS

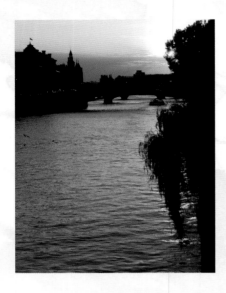

PALETTE

+ Cadmium Orange

+ Cobalt Blue

+ Quinacridone Burnt Scarlet

+ Ultramarine Blue

+ Burnt Sienna

+ Phthalo Green

+ Carmine

REFERENCE PHOTO

This is the reference photo for this demonstration. Note that it is printed in black-and-white to emphasize the values without the influence of color.

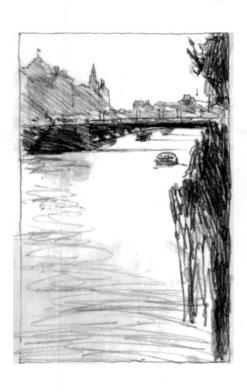

1 THE VALUE STUDY

Use the basic information from the photo and do a pencil value study. Note the differences between the photo and the study: The background is lighter to accentuate the illusion of distance, and the boat is moved to create a stronger focal point.

It's important to choose the elements you want from a photo reference. Don't let the photo dictate your choices; it's only a reference.

2 THE PENCIL LINE WORK

Do a careful pencil line drawing on a piece of watercolor paper (in this demonstration, I'm using Arches 140-lb. cold-press paper). Use a soft pencil, such as a 2B (harder leads can scratch the paper). It isn't necessary to put all of the information on the paper. You just need enough so you can concentrate on the painting and not worry about the content. On the other hand, though, without enough information you can get distracted by thoughts like "What was I going to do here?" rather than think about the process of painting.

3 THE UNDERPAINTING

To convey a sunset evening, start with a Cadmium Orange to Cobalt Blue gradated wash in the sky area, blotting out some of the wash to suggest the setting sun. Continue the Cobalt Blue wash through the building areas. Then clean out your brush and, using clear water, drag your bead into the water area around the boat, preserving the white of the paper around the focal point. Then re-introduce the Cadmium Orange, washing down the page, gradating from light to dark at the bottom. While the wash is still damp, drop in a heavier wash of Cobalt Blue, wet-in-wet, in the water to indicate waves and reflections.

Remember, this is one big wash from top to bottom. Doing it as one wash helps to tie the entire painting together.

4 THE BACKGROUND

The background is painted wet-in-wet using Cobalt Blue and Quinacridone Burnt Scarlet. If you are left-handed, as I am, start on the right side to avoid putting your hand in wet paint. If you're right-handed, it's best to start on the left (see Step 5). Most important, keep the wash fairly light to indicate the background is far away.

 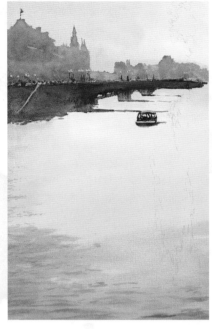 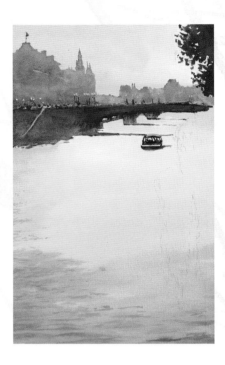

5 MORE BACKGROUND

Whether or not you start from the left or right, complete the background. Note how it is mostly a large shape, without very much detail. Backgrounds, in general, can be treated simply and indistinctly, helping to set off the more detailed painting in the mid-ground and foreground.

6 THE UNDERPAINTING

Using a heavier wash of the background colors, Cobalt Blue and Quinacridone Burnt Scarlet, and adding some Ultramarine Blue and Burnt Sienna, paint the bridge and the boat wet-in-wet. Keep in mind that the bridge, its reflections and shadows and the boat are, just like the background, shapes without much detail.

7 THE BACKGROUND

Using a dark mixture of Phthalo Green, Carmine and Quinacridone Burnt Scarlet, begin the foreground tree. These colors are painted wet-in-wet. First lay down a 2% milk–consistency wash of Quinacridone Burnt Scarlet and then lay down a yogurt-consistency wash of the other two colors. Pay particular attention to the irregularity of the edges of the tree shape.

For this wash, as for most washes, start at the top of your tilted paper, allowing the bead of water and pigment to move down the paper. Gravity is your friend. It also helps keep your brush-hand clean, since you don't have to put your hand in wet paint.

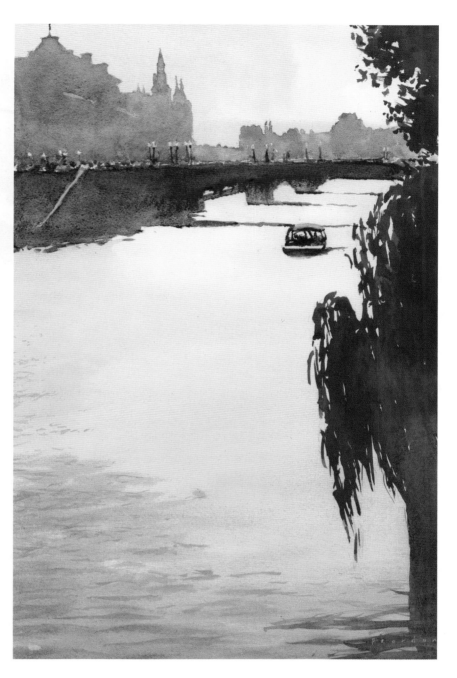

DETAIL

In this detail you can see the richness of wet-in-wet painting, contrasted with the smoother quality of the initial gradated wash in the sky and water. Note how the pigments in the wet-in-wet washes intermingle.

Also, observe how the street lamps were "painted around" during the painting of the background, leaving them lighter than the background. Of course, they can be lifted afterward, if you prefer, or painted in with an opaque white paint.

8 FINISHING UP

Continue down the page, painting the tree with the same mixture as in Step 7. When you reach the bottom, change the paint mixture to the same colors as in the midground, Quinacridone Burnt Scarlet, Ultramarine Blue and Cobalt Blue. Allow the tree wash and the river wall to blend together. At the very bottom, drag some of the Cobalt Blue into the water to create some darker waves.

Note how much of the painting was done during the underpainting. The sky, water, reflections, lighting and mood were all done in about five minutes of painting.

49

CHEMIN DE LA DORDOGNE
14" × 9" (36cm ×23cm)
This painting shares many of the same techniques seen in the demonstration. The underpainting took care of the sky and path—about 75 percent of the painting—using Cadmium Orange and Cobalt Blue.

As with *Morgan Horse Ranch*, the path helps lead your eye into the painting.

MORGAN HORSE RANCH
14" × 7" (36cm × 18cm)
Much of this painting was done wet-in-wet, including the sky and background. This technique is particularly effective in evoking a soft and misty day.

Note how the road leads your eye into the painting. Streets, sidewalks and paths can be very useful compositional devices.

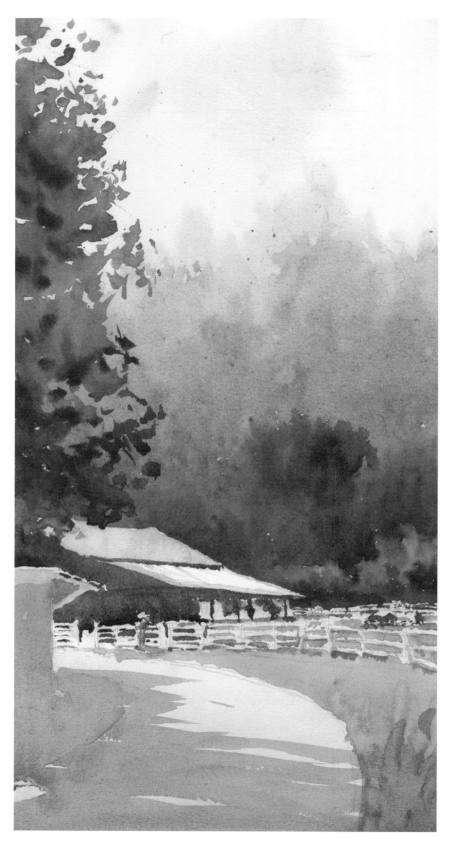

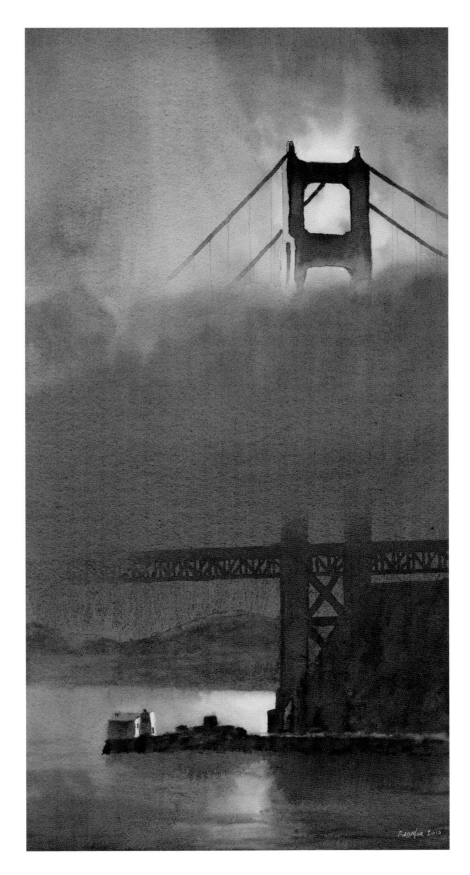

NORTH TOWER NOCTURNE
22" × 11" (56cm × 28cm)
You can see evidence of the wet-in-wet technique in this painting. After the underpainting was completed, almost all of the painting was done by dropping colors into moist pigments.

Timing and patience is critical. Sometimes you just have to step away for a few minutes to let the paint dry a bit before you paint an adjacent area. Otherwise areas bleed, yielding an unhappy mess.

On the other hand, wet-in-wet can achieve a full array of delightful color mixtures, seductive edge conditions and, above all, the unique luminosity of watercolor.

THE ARCHITECTURE OF WATERCOLOR

◆

Watercolor has been used to paint architectural subjects for a very long time. Perhaps most famously, John Singer Sargent's watercolors of Venice and Italy demonstrate how watercolor and architecture work well together. The Ècole des Beaux-Arts in Paris exclusively used watercolor for its architectural drawings.

To depict architecture requires some aptitude with perspective and some understanding of light and shadow. In this chapter, we cover the basics of these tools in a way that makes painting buildings a pleasure, even for those who cringe when they hear the word *perspective*.

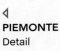

◁
PIEMONTE
Detail

PERSPECTIVE

To do a basic drawing in perspective requires two elements: a horizon line and vanishing points. Some drawings require only one vanishing point (one-point perspective) while others require two or more.

The horizon line is simply a horizontal line across the page that corresponds to your eye level. Think of a view of the ocean. The far horizontal line is the horizon, hence a horizon line. A similar unseen line exists in all paintings in perspective.

Lines that converge at the vanishing point(s) create the illusion of perspective. Put simply, all of the lines of one side of a building radiate from one vanishing point, and the lines on the other side converge on the other vanishing point.

Many images, such as cityscapes, often only have one vanishing point. These are known as one-point perspectives. The second vanishing point is so far away that all of the lines are horizontal.

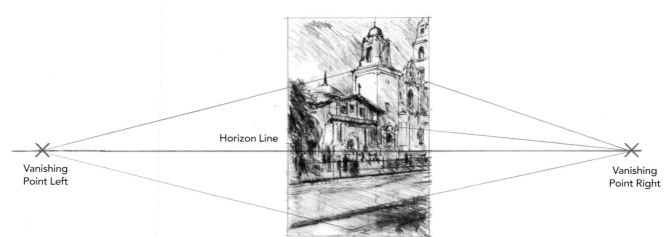

Horizon Line

Vanishing Point Left

Vanishing Point Right

TWO-POINT PERSPECTIVE

In this eye-level view you can clearly see the eye-level line of the horizon line. In such a view, all of the heads of the people are at or near the horizon line.

Note how all of the lines on the left side of the buildings converge at the left vanishing point and how the right side lines converge on the right vanishing point.

I always do a quick pencil study before I paint to determine the horizon line and vanishing points.

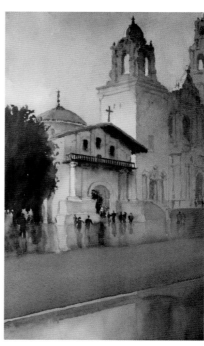

MISSION DOLORES, SAN FRANCISCO
14" × 9" (36cm × 23cm)

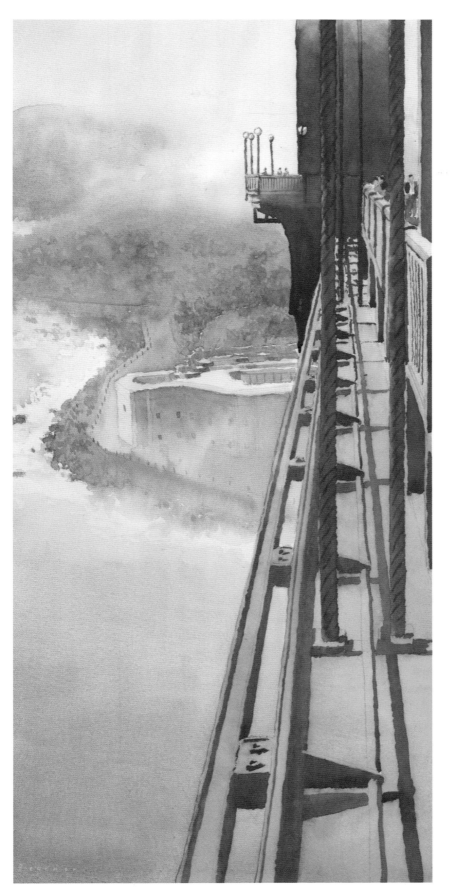

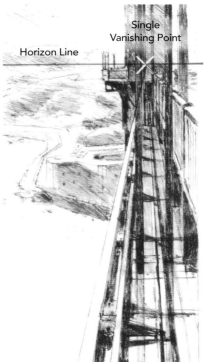

Horizon Line

ONE-POINT PERSPECTIVE

The vanishing point in a one-point perspective falls within the borders of the image. In this case, the vanishing point is similar to the right vanishing point on the facing page. The left vanishing point is so far to the left that the lines look horizontal.

The horizon line is at eye-level for a person on the bridge. The vanishing points for the fort below also fall on this elevated horizon line. Note how the heads of the distant people touch the horizon line.

One-point perspectives are especially useful in street scenes, with buildings receding in the distance toward a single vanishing point.

◁
GOLDEN GATE BRIDGE OVERLOOK
22" × 11" (56cm × 28cm)

CIRCLES AND SQUARES

In my plein air workshops I have noticed that drawing circles or curves in perspective bedevils many people, especially when the circles or curves occur near the horizon line. At the horizon, circles and curves flatten out into a single horizontal line, yet the tendency of many people is to draw a curved line, because their brains say it's curved. Circles and curves remain a very shallow curve near the horizon line, gradually increasing in size as they get further away.

On the other hand, drawing squares in perspective seems to be easier to do and is useful in determining proportions when painting outdoors. I commonly draw squares during my study sketch and pencil line drawing to determine the correct proportions of buildings.

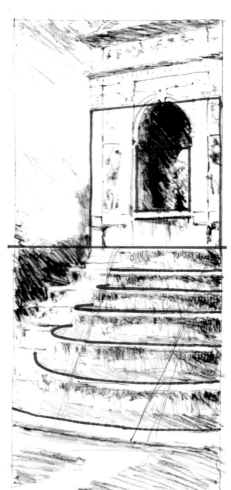

Horizon Line

FONTAINE DES INNOCENTS, STUDY

You can see the gradual increase of the size of the curve of the basins as they get further away from the horizon line. Note how the curve at the horizon line is completely flat. It is sometimes helpful to think of circles in perspective as ellipses that get larger and larger as they get further from the horizon line.

Drawing squares to judge proportions in perspective is particularly useful when painting plein air. The squares allow you to judge the size of architectural elements and their relationship to each other.

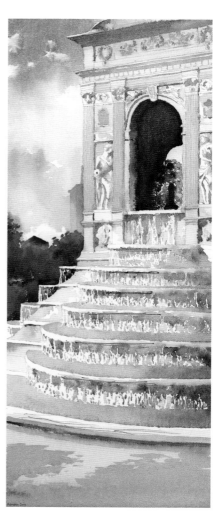

FONTAINE DES INNOCENTS, PARIS
25" × 14" (63cm × 36cm)

ATMOSPHERIC PERSPECTIVE

Perspective is a means to create the illusion of depth in an image. According to Leonardo da Vinci, there are more ways to imbue your artwork with a sense of space than the linear perspective discussed on the previous pages.

Leonardo da Vinci wrote extensively on perspective. He considered atmospheric perspective on a par with linear perspective. When you look at the Mona Lisa, note how the background is less defined and lighter in value than La Gioconda. By making your backgrounds more ethereal you can, like da Vinci, accentuate the depth in your watercolors.

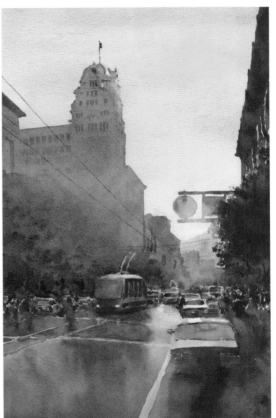

△
MARKET STREET, SAN FRANCISCO
20" × 14" (51cm × 36cm)

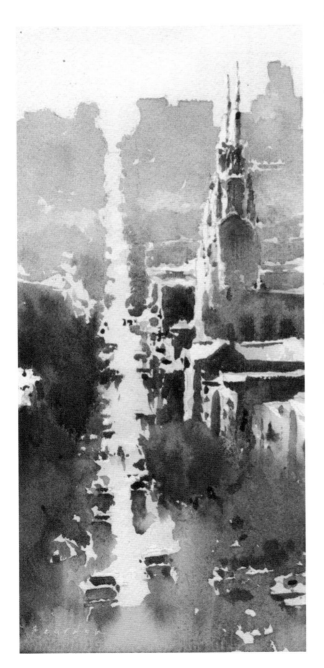

◁
FILBERT STREET, SAN FRANCISCO
13" × 7" (33cm × 18cm)

Note how the backgrounds in both of these paintings are less defined. In reality, there was considerably more detail in the backgrounds, but I simplified them as shapes. This lack of definition helps to set off the more carefully rendered foregrounds and middle grounds.

LIGHT, SHADE AND SHADOW

Depicting light is perhaps one of the greatest strengths of watercolor, making it a perfect medium for portraying architecture. The play of light across a sunlit surface can easily be painted with a few light washes.

It's watercolor's facility to depict shade and shadow that is its true strength. A wealth of warm and cool colors are reflected into the shaded and shadowed parts of buildings. More than anything, shade and shadow define architecture. Keeping your colors lively in these areas will yield more dynamic paintings.

When approaching an architectural subject, it is useful to ignore the subject. Instead, squint to discern the pattern of light, shade and shadow. It takes some practice, but if you can disregard the subject and simply judge the pattern of light and shadow, your paintings will generally be more successful. The abstract pattern created is the core of your composition.

It is the quality of light that makes a building sing or look flat. By imbuing architecture with a strong sense of light, your watercolors will glow.

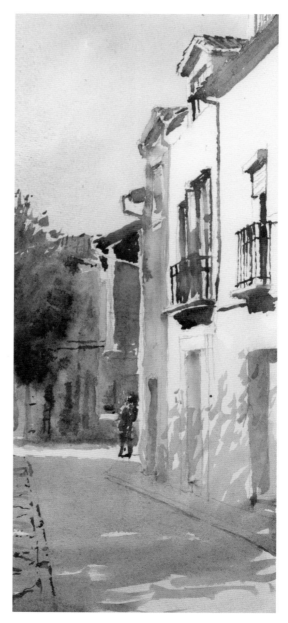

▷
CALLE DEL CONVENTO, HERVAS, SPAIN
14" × 6" (36cm × 15cm)
The shade and shadow gives architectural subjects their form. Note how the shadows on the upper part of the building define the top edge, while the areas in shade give it depth. The sunlit part of the building is almost unpainted. It is the shade and shadow that does most of the work. Note also the use of a one-point perspective, a useful device for portraying street scenes.

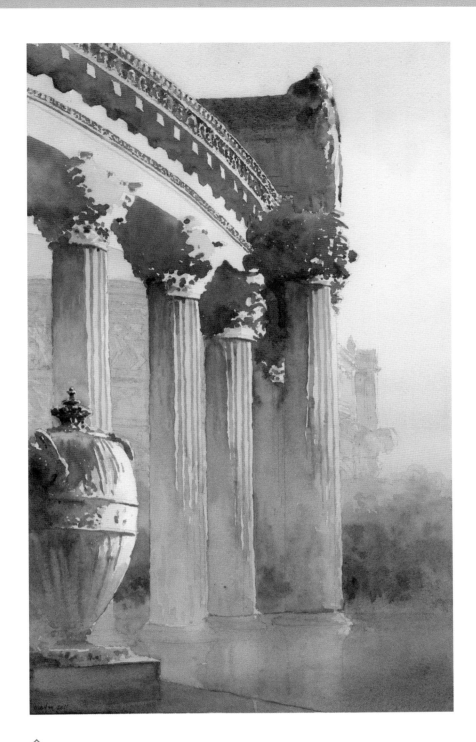

PALACE OF FINE ARTS, SAN FRANCISCO
18" × 11" (46cm × 28cm)

Note the washes of warm orange on the sunlit portions, migrating to cool blues as they descend the columns. These subtle changes of hue create a sense of warm and cool light that sparkles due to the deep values in the areas of shade and shadow.

Pay careful attention to bounced light in architectural subjects. In this painting, note the orange hue in the undersides of the structure, reflecting the warm light from the ground plane. The cool blues on the ground and in the shadows reflect the colors of the sky.

The next time you are looking at a light-valued structure, observe the warm colors you see on the undersides of buildings and the cool colors of the shadows. Of course, if you have a warm orange sky, the shadows will be a warm shade. These shifts of hue are subtle but will yield lively and more realistic results in your paintings of architecture.

ALCATRAZ ISLAND LANDING

PALETTE

+ Cobalt Blue

+ Cadmium Orange

+ Cobalt Turquoise

+ Quinacridone Burnt Orange

+ Carmine

+ Phthalo Green

+ Carmine

+ Quinacridone Burnt Scarlet

REFERENCE PHOTO

The intention of this painting is to portray the Alcatraz Island boat landing on a cold and misty morning. The triangular composition and the contrasting verticals and horizontals form an appealing arrangement of shapes.

1 THE VALUE STUDY

In your pencil study sketch, indicate the vanishing points. In this case, there are two right-hand vanishing points. Because they are at an angle to each other, each set of buildings has its own set of vanishing points.

The right-most buildings have a vanishing point far to the right (VP1). The left-most buildings have a vanishing point within the picture frame (VP2), making them virtually one-point perspectives.

The left vanishing points are far off to the left. It's easiest to make the lines for these buildings almost completely horizontal rather than find their vanishing points.

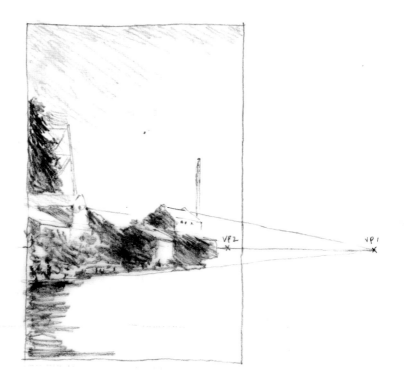

2 THE PENCIL LINE DRAWING

Using a 2B pencil, carefully draw the outlines of the image onto 140 lb. cold-press paper. Don't be afraid to make your lines dark. They will mostly disappear after paint is applied. It is important to be able to see your lines.

When complete, tape the paper to a heavy piece of cardboard or Masonite. Use a good quality masking tape.

Tilt your board to at least a 15-degree angle. I use a French easel to do this.

3 THE UNDERPAINTING

By mixing Cobalt Blue and Cadmium Orange, create two large washes of gray. One is bluer and one is warmer, with more orange added.

Starting at the top, mix a blue-gray wash and do a gradated wash down the page, introducing the warmer gray as you reach the horizon. Paint around the white faces of the buildings, leaving the white of the paper showing.

Continue the wash past the horizon and into the water area. Then create a gradated wash from warm to cool. Add some Cobalt Turquoise into the blue-gray wash, making the water area slightly darker than the sky and an appropriate hue for the water.

4 THE BACKGROUND

Create a slightly darker gray by mixing the Cobalt Blue and Cadmium Orange. It should be more like a 2% milk consistency, rather than the non-fat milk consistency used for the underpainting.

Paint the distant water tower and give a slight hint of a darker sky at the horizon.

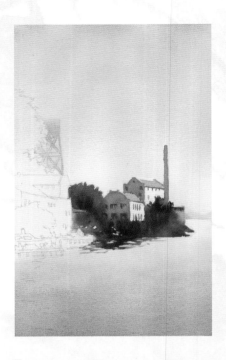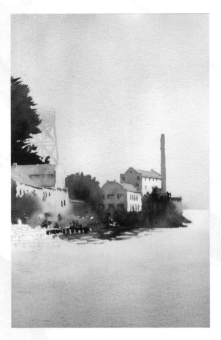

DETAIL

This detail shows how some of the washes bleed into other washes, creating soft edges and a more suggestive effect.

Note how the windows were added, using a slightly heavier and darker wash of gray. A light wash of Cadmium Orange on the roofs completes this area.

5 THE BUILDINGS AND TREES

If you're left-handed, begin with a gray mixture of Cobalt Blue and a bit of Quinacridone Burnt Orange, and paint the exhaust pipe, working from top to bottom. (If you're right-handed, you might want to start with Step 6, working from left to right.) Drag this mixture across the shadow lines and shaded areas of both buildings, linking the shapes together.

Paint the trees by laying down a light wash of Quinacridone Burnt Orange over the entire tree area, followed by a creamy mixture of Carmine and Phthalo Green, and occasionally Quinacridone Burnt Scarlet, while the wash is still damp. Working wet-in-wet gives the trees a lot of variation and life. After completing the entire area, drag some of the wash into the water to create reflections.

Before the wash is completely dry, mix Phthalo Green and Carmine to a thick, yogurt consistency to create some almost black areas.

6 MORE BUILDINGS AND TREES

Starting with the background tree, cover the entire tree with a 2% milk wash of Quinacridone Burnt Scarlet. While damp, drop in a creamy mixture of Carmine and Phthalo Green, covering the entire tree.

Using a gray mixture of Cobalt Blue and a bit of Cadmium Orange, paint the shade and shadow areas of the buildings. While the paper is still a bit damp, paint the roofs with Cadmium Orange, allowing it to bleed a bit with the shaded area.

Paint the lower trees just as above, but instead of Carmine, use Quinacridone Burnt Scarlet and Phthalo Green as your mixture. Create variety by letting the edges bleed a bit, dropping a bit of Cadmium Orange near the bottom. Note how the buildings aren't pure white: There's a light gray wash over the entire area. This way the pure white buildings to the right remain the focal point.

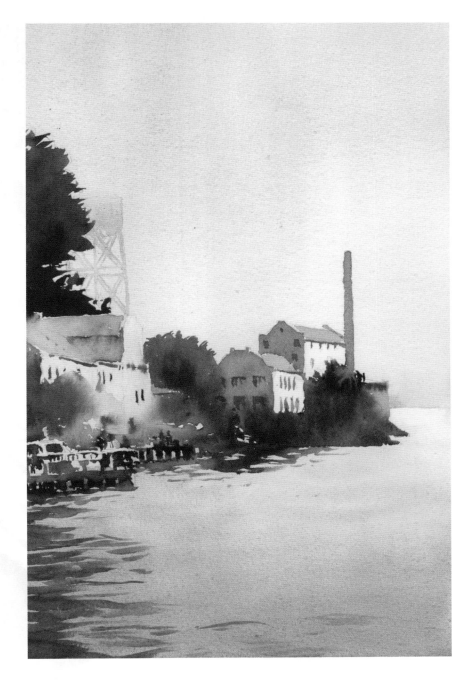

7 FINISHING UP

Complete the dock area using Cobalt Blue, Quinacridone Burnt Orange, and a black mixture of Carmine and Phthalo Green for the undersides of the piers. This area can be painted very impressionistically, since it isn't the focal point. Suggestion is all that is needed.

Finish the painting by adding the wave pattern, using Cobalt Turquoise and a bit of Phthalo Green and Quinacridone Burnt Scarlet to gray up the mix. Using horizontal strokes, start with the wash under the piers and drag it down and across the page.

Note how the focal point remains on the buildings on the right, the only place in the painting where black and the pure white of the paper coincide.

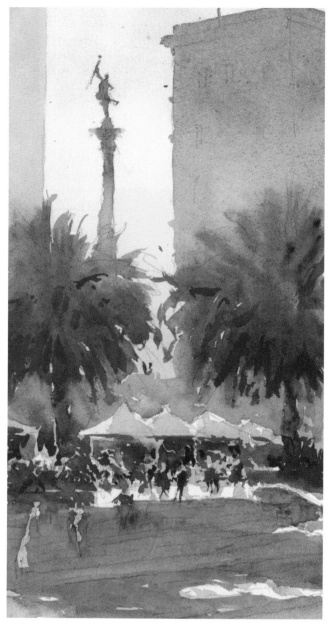

UNION SQUARE, SAN FRANCISCO
10" × 5" (25cm × 13cm)
This is a quick 45-minute sketch of San Francisco's main square. Since the story was about the event tents and the activity on a fall afternoon, the background buildings are left as silhouettes. This treatment not only guides attention to the focal point but also evokes the soft light of a November afternoon.

700 MARKET STREET, SAN FRANCISCO
18" × 11" (46cm × 28cm)
When painting architecture, it isn't necessary to paint the entire building. In this case I was most interested in the top, so I faded out the rest.

Note the extreme perspective. Where the two sides meet is 90 degrees or more. When they become less than 90 degrees, buildings look distorted. Keep this in mind when painting the tops of buildings.

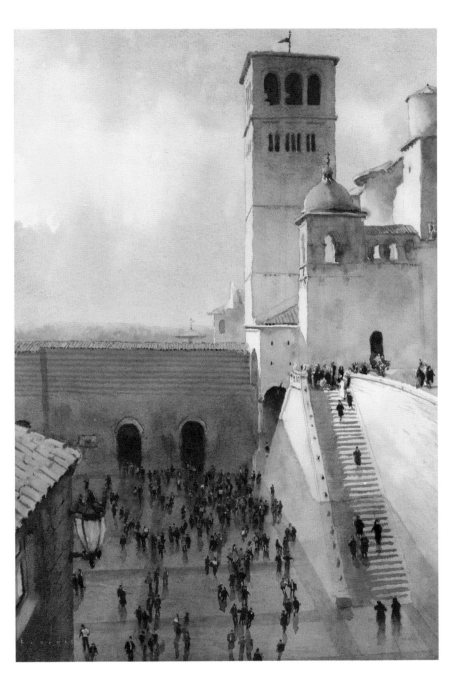

◁

PIAZZA INFERIORE DI SAN FRANCESCO ASSISI
23" × 14" (58cm × 36cm)
This shows the value of a one-point perspective. The horizon line is at the eye level of the people on the plaza, the focal point. The converging lines of the perspective help to send the viewer's eyes to those people, emphasizing the focus. This painting also illustrates the importance of choosing a viewpoint. By using this elevated horizon line, both plazas, linked by the staircase, can be shown.

5

THE VALUE OF LIGHT

◆

The quality of light in a painting is strictly due to the arrangement of values. Color has
but a peripheral role in creating a light-filled watercolor.
This chapter discusses the use of values and their role in watercolor. Developing
an intuitive feel for values will greatly enhance your painting experience.

◁
ALTAMIRA
Detail

VALUE VERSUS COLOR

There is an ongoing debate regarding the relative importance of value versus color in representational painting. Many artists feel that a value plan is all that is necessary. For them, color is subsidiary to value. Colorists, on the other hand, feel that color is most critical and that patterns of color make a successful painting and that the value scale is intrinsic in the colors.

I'm not going to take sides in this debate, although I lean towards the values argument. The more I paint and teach, the more I believe a strong value plan is imperative. Even after decades of painting, I continue to do a pencil value study prior to every painting. With my values determined, I can then select the colors that I need to yield these values.

Many students, who are often reluctant to do a value study, get lost somewhere in the middle of a painting or have to go over previously painted areas because they didn't know the values they wanted in advance. While color is crucial, following a solid value plan is a sure road map to a successful painting.

Value and light fit hand in glove. They are inseparable. Through the deft use of values, a painting can evince a strong sense of light, depicting a range of effects from harsh midday sun or soft and misty light. Value manipulation defines the atmosphere and feeling of light.

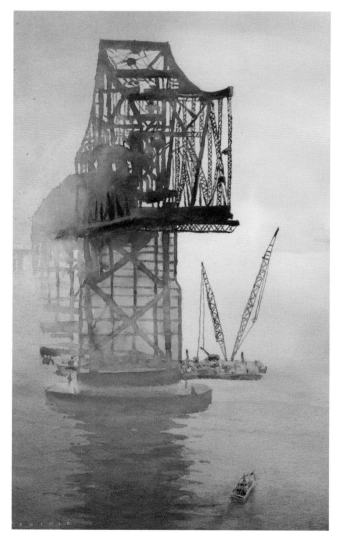

▷
BAY BRIDGE DEMOLITION
Gray Scale Version
It can sometimes be useful to convert an image to gray scale to better discern the values independent of the color.

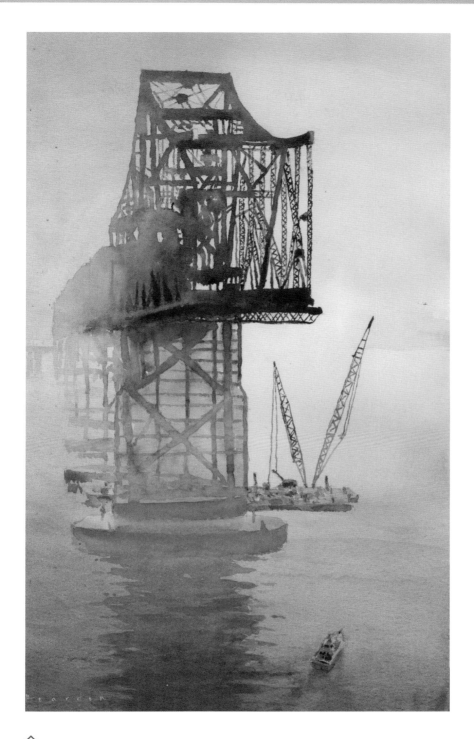

BAY BRIDGE DEMOLITION
18" × 11" (46cm × 28cm)
This painting is composed almost entirely of areas of value, with a very limited color palette.

A sense of distance is created by the mid-values as the bridge recedes, transitioning to the lighter values of the distant bridge. When depicting three-dimensional space on a two-dimensional piece of paper, it is often necessary to exaggerate the depth. Values can help you do this.

Color plays a supporting role in the painting. For example, the muted color scheme evokes the feeling of early morning light. Changing the colors would change the feeling of the painting. Color modifies the mood, while values establish the composition.

VALUES

Values are a range of tones that span from pure white to pure black. On a scale of 1 to 10, white has a value of 1, while black has a 10. 1 to 3 are considered light values. 4 to 7 are mid-range values. 7 to 10 are dark values.

In watercolor, the water-to-pigment ratio creates values. That means that the more water you add to the pigment, the lighter the value. Or, vice versa, the more pigment you add to water, the darker the value. This manipulation of values is the backbone of watercolor painting.

Many paintings with a limited value range are quite convincing. A painting that has only light values is known as a high-key painting. A limited shift of values often yields an evocative painting. Soft and hazy lighting usually has few jumps in value. The closer the values are overall, the weaker the light.

Paintings that have the full range of values are very dynamic. By using the full gamut of values, you have many more tools at your disposal to create a sense of light. A wide range of the mid-value tones, coupled with the light and dark values, creates a treat for the eye. Value composition lights up a painting and sets the mood.

| 1 | 2 | 3 | 4 | 5 | 6 | 7 | 8 | 9 | 10 |

VALUESCALE

NON-FAT MILK 2% MILK WHOLE MILK CREAM YOGURT

In watercolor, value is determined by the ratio of water to pigment in a mixture. The more water, the lighter the value. The more pigment, the darker the value.

The use of the dairy scale described in Chapter 3 is key to creating a full range of values. For the lightest values you'll use non-fat milk or a 2% milk consistency. For the medium to dark values, you'll use whole milk, cream, or yogurt consistency pigments.

Though some pigments are slightly darker than others, there isn't a dark tube or a light tube in watercolor. The value of a color is achieved only by varying the ratio of pigment to water.

Everyone soon discovers that watercolors dry lighter than they look when they are first applied. You usually have to apply the paint higher up the value scale to get the value you want.

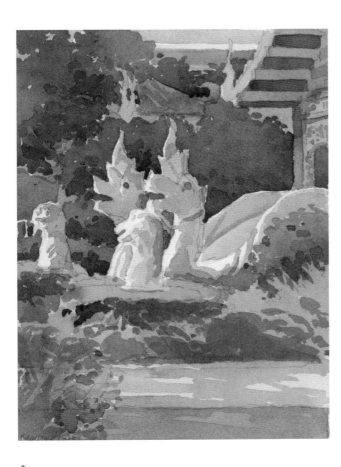
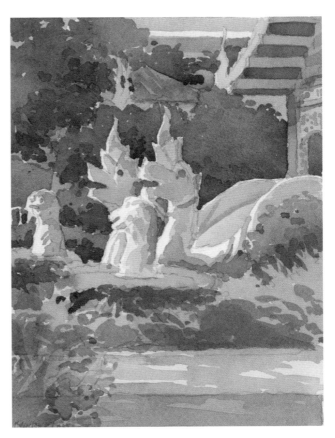

WAT PHRA SINGH, THAILAND
8" × 6" (20cm × 15cm)
When the color version is converted to gray scale you can clearly see the inherent values. For example, the value of the red under the eaves is the same as the green trees behind the sculptures. Notice also that the various shades of white are all light in value, though not pure white.

THE VALUE OF COLOR

None of the primary hues possess the full value range of 1 to 10. Yellow, for example, rarely gets beyond a 3 in value. Reds and blues have a greater range, but never get to 10 on their own. They must be mixed to reach a true black. Generally the staining colors have the greatest range. For example, I make black by mixing Phthalo Green and Carmine. Cobalt Blue is strictly a mid-range hue. No matter which colors are mixed with it, it will never get very dark. It is very important to know which colors have large value ranges and which have small ones. Since watercolors dry so much lighter than when wet, it is very common to think you have painted a rich, dark color when in fact it's a mid-range value when it dries.

1 2 3

1 2 3 4 5 6 7 8

CARMINE

Generally reds have a scale of 2 to 8. These include the powerhouse reds, such as Carmine and Alizarin Crimson. There are some weak reds, such as Rose Madder, that only reach 2 to 5 or so.

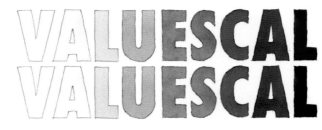

1 2 3 4 5 6 7 8 9

PHTHALO BLUE

Blues have a similar value range to the darker reds, with some variations. Phthalo Blue can be a 9 on the value scale. Cobalt Blue and Cerulean Blue only reach a 6 or 7.

BISMUTH VANADATE YELLOW

All yellows have a limited value range, from 2 to 3. Bismuth Vanadate Yellow, a relatively strong yellow, reaches a value of 3 at full strength. Some yellows, such as Aureolin, are very weak and have a value range of perhaps 2. You can never make a dark yellow.

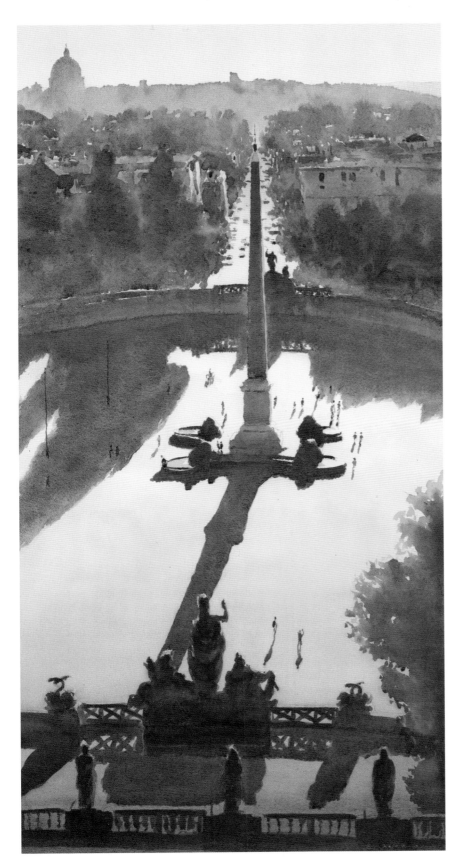

PIAZZA DEL POPOLO, ROME
28" × 14" (71cm × 36cm)

Note the values of the deep blue shadows. On a value scale, they achieve about an 8, even though they are painted at almost full strength.

The color base is Cobalt Blue mixed with a bit of Quinacridone Burnt Scarlet to increase the value range and give it a slight purple tint. I often use this mixture in place of Ultramarine Blue, which granulates more than this mixture.

The true black areas are a mixture of this deep blue with Phthalo Green and Carmine, also close to full strength.

The red tile roofs in the distance are painted with a dense mixture of Cadmium Orange. The same Cadmium Orange is in the plaza foreground, almost fully diluted. The water to pigment ratio is key to achieving the correct values in your painting. By knowing the range of individual colors, you can mix the values you desire.

◆

All colors can be made light.
Not all can be made dark.

◆

PRAYER WHEEL, BHUTAN

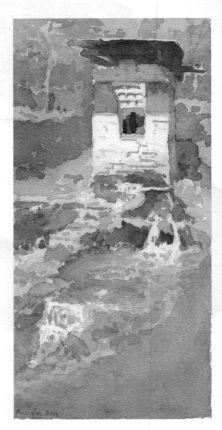

PALETTE

+ Cobalt Blue

+ Cadmium Orange

+ Viridian

+ Quinacridone Burnt Scarlet

+ Phthalo Green

+ Ultramarine Blue

+ Quinacridone Burnt Orange

+ Cobalt Turquoise

+ Cadmium Red

+ Carmine

REFERENCE SKETCH

For this demonstration I am using a sketch I did while trekking in Bhutan.

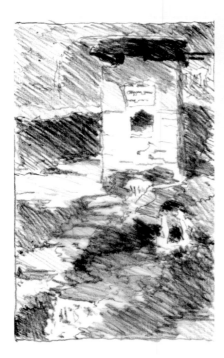

1 THE VALUE STUDY

Complete your value study. The main difference between the reference sketch and the value study is that I cropped the foreground in the study and created a lighter background.

2 THE LINE DRAWING AND UNDERPAINTING

Do the pencil line drawing on 140-lb. cold-press watercolor paper and tape it to a board or support.

Start at the top, using weak mixtures of Cobalt Blue and Cadmium Orange, and cover the entire page. Preserve the white of the paper for the building body and the three waterfalls.

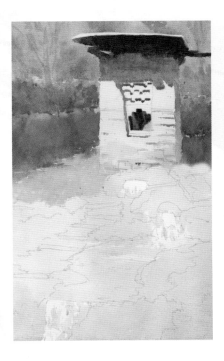

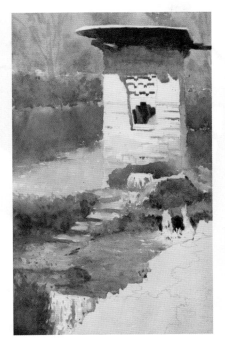

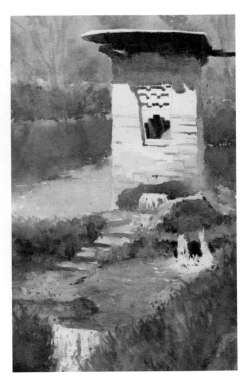

3 THE BACKGROUND AND BUILDING

First do the background trees, using Cobalt Blue, Viridian and some Quinacridone Burnt Scarlet. Continue into the middle ground shrubs, introducing Phthalo Green with the other colors to create darker greens. Some Cobalt Blue shadows finish the shrubs.

When the background is dry enough, paint the building. Using Ultramarine Blue and Quinacridone Burnt Orange in a creamy mixture, paint the black underside, leaving some of the orange showing through. Immediately introduce the Cobalt Blue shadow areas, dragging some of the darker mix into it. Then use the same black mixture on the central opening.

4 THE WATER AND STEPS

Bring the wash down from the shrubs on the right, dragging it across to paint the moss growing on the building. Using Ultramarine Blue, Cobalt Blue, Quinacridone Burnt Orange and Cadmium Orange, modulate the stones and steps, darkening the risers as the wash dries. Finish the shrubbery on the left of the stairs with the same green mixture you used in Step 3.

Darken the area around the double falls with the same black mixture used in Step 2. For the water use Cobalt Turquoise and drag some of the adjacent washes into the mixture. Leave some sparkles unpainted.

Complete this all the way down to the left bottom of the paper. Using the same green mixtures as before, paint the shrubs in the lower left. Cast some shadows using Cobalt Blue.

5 THE FOREGROUND AND FINISHING TOUCHES

Paint the foreground shrubs with the same green mixture you used before, using mostly Phthalo Green and Quinacridone Burnt Scarlet. Paint the red areas of the building, using Cadmium Red, Carmine and the Burnt Scarlet to create some variation in the color.

After comparing the result with the value study, darken the shrubs adjacent to the building and the shadow area around the double falls if necessary.

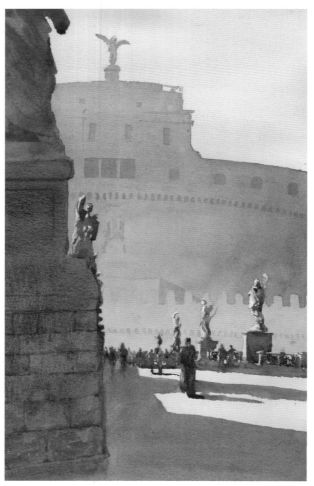

CUSTOMS HOUSE, SAN FRANCISCO
11" × 18" (28cm × 46cm)
Using a full range of values creates richness and sparkle. There are many dark values in this painting. The only one that is juxtaposed with a white area is the head, the focus of the painting.

Note the subtle values achieved within the dark areas. They are all 7 to 10 on the value scale, and work together to create the three-dimensional feeling. Canaletto once noted that all the details are in the shadows. Indeed.

PONTE SANT'ANGELO, ROME
18" × 11" (46cm × 28cm)
Note the light value of the background Castello Sant'Angelo. In reality, the building has a much larger value range and more detail. By using a light value and simplifying the detail, the building recedes, allowing the subject of the painting—the figures on the street—to be emphasized.

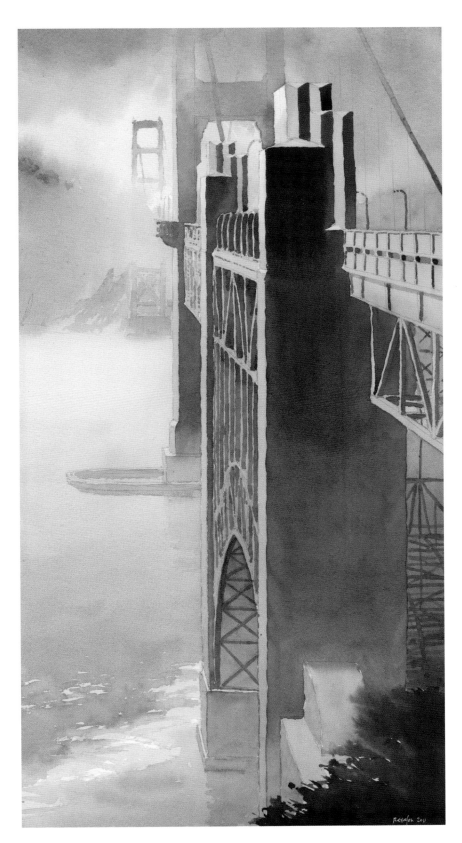

SOUTH ANCHORAGE, GOLDEN GATE BRIDGE

22" × 11" (56cm × 28cm)

The sense of light in this view is created from the juxtaposition of contrasting values. The white of the paper is preserved on the anchorage, the light through the fog in the distance and the waves below. The black of the foreground pier creates a strong contrast against the sunlit side, drawing the eye to the focal point, the spot of greatest value contrast. The other light areas suggest the light but are secondary to the focal point. Manipulating these values evokes an illusion of distance and the feeling of a misty San Francisco evening.

If you get the values right, you can do almost anything with the color, and the painting will work.

VALUES AT WORK

◆

The arrangement of values is key to portraying the illusion of three dimensions on a two-dimensional surface. In this chapter we discuss many of the elements that work together to achieve this effect, including value studies, composition and patterns of light and shadow.

LYCIA
Detail

STUDYING VALUE

A value study is like a road map showing the way to make a successful painting. When painting plein air, for example, many subjects and extraneous details confront the artist. A quick thumbnail sketch can boil the scene down to its essentials. Using a pencil enables easy changes, allowing you to explore possibilities before committing to the immutability of watercolor.

Keeping sketches small—no larger than 6″ (15cm) or so in the long dimension—forces you to concentrate on the main shapes and simplify the details. At the sketch stage you can easily correct compositional problems, such as bisecting the painting with the horizon line or the lack of a focal point, and eliminate unnecessary details.

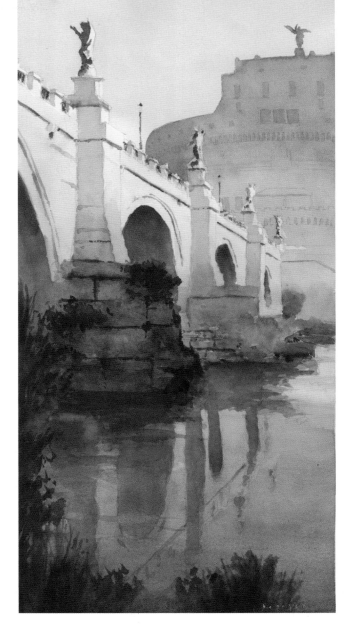

▷
PONTE SANT'ANGELO, ROME
13″ × 6½″ (33cm × 17cm)
You can see that the overall value scheme and composition are achieved in the value sketch.

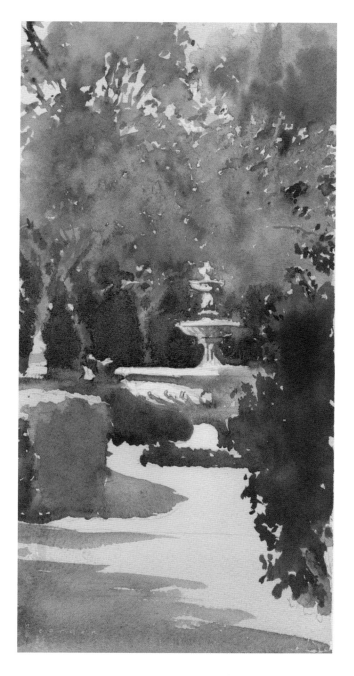

MILLS COLLEGE FOUNTAIN, OAKLAND

13" × 6" (33cm ×15cm)

Studies can be very small and take only five or ten minutes to complete. You can see that my compositional decisions and the specific lighting conditions are also nailed down.

The value sketch shows how the shapes are simplified. What isn't apparent is that I moved a few elements, such as the clipped hedge on the left, which was much closer to the fountain. I felt it needed more breathing space so the eye would travel to the fountain. It is this kind of decision that can be easily made in pencil and not while painting.

THE SKETCHBOOK

A 6" × 8" (15cm × 20cm) ring-bound sketchbook is ideal. Note the size of the actual sketch in relation to the size of the sketchbook.

The few minutes it takes to do a value study saves countless frustrating minutes struggling to save a painting.

THE VALUE OF HIERARCHY: FOREGROUND, MIDGROUND AND BACKGROUND

Most paintings succeed when they have a foreground, middle ground and background. If you look at representational paintings in any museum, these three spatial areas are almost always present.

I always use a value sketch to help define the values for these three areas. As a general rule, each should have a different tonal range. A typical arrangement is a light-valued background, a middle ground with medium values, and a dark-valued foreground. These of course can be interchanged. This compositional trio is a powerful organizing principle in all landscape compositions.

PORT CRANES, OAKLAND, CALIFORNIA
14" × 9" (36cm × 23cm)
This is a classic example of a light background, a middle-valued middle ground and dark-valued foreground. This arrangement is very effective in creating the illusion of depth, as if the watery mist from the port diffuses the light the farther back you go.

Using a well-defined foreground, middle ground and background will usually lead to a well-organized composition.

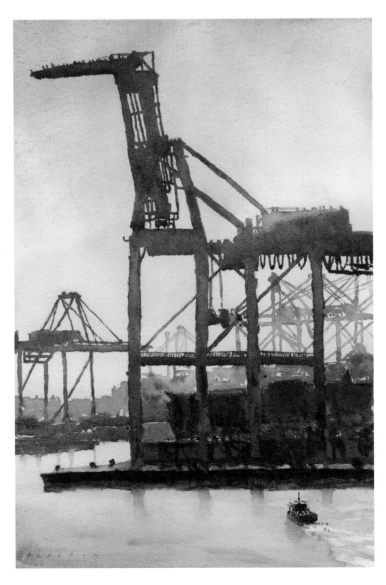

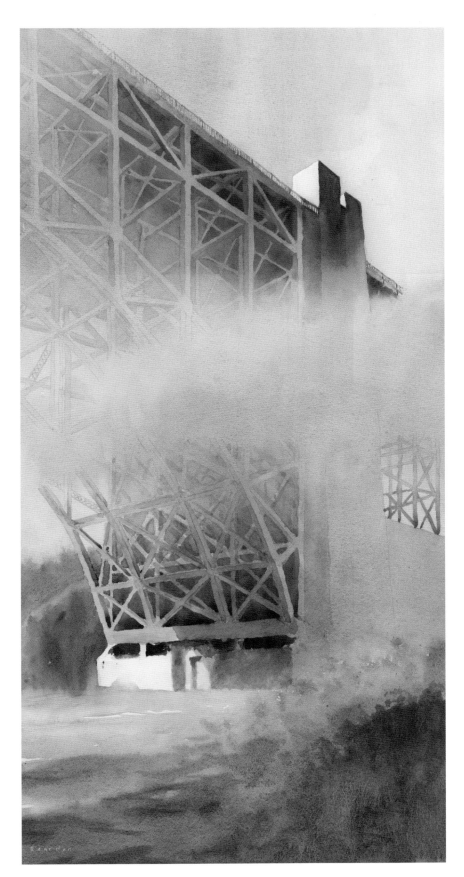

◁

SOUTH ANCHORAGE, GOLDEN GATE BRIDGE
28" × 14" (71cm × 36cm)

foreground: waves
middle ground: bridge
background: hills

In this case the foreground is medium valued, and the middle ground has the darkest values. As is almost always the case, the background is light valued.

Below is my value sketch. Even with large paintings, I always do value sketches. I didn't include the medium value on the foreground wave since I already had a picture in my head.

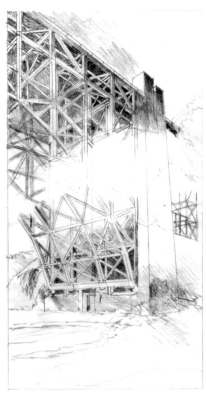

SHASHAPES AND VALUES

Compositions are a collection of shapes that are arranged into a pleasing abstract pattern. Understanding how to do this is a lifelong process. For centuries people have tried to create rules that govern composition, such as triads, the golden ratio and too many others to discuss here. It is worth knowing these rules, but ultimately composition becomes intuitive; you know when something is right or wrong. Experimentation is best.

The value sketch will help you to simplify and refine the shapes. There are many ways to simplify, such as linking shadows or negative spaces into a single shape. A quick pencil sketch allows you to arrange the shapes to make a harmonious composition. Linking shapes helps to knit a painting together and will help to unify your painting. You can easily change the shapes in your sketch until you are satisfied with the arrangement.

When doing a study sketch, I try not to focus on the subject matter but rather on the various shapes and the values of those shapes. This takes some practice. The ability to break a scene into a pleasing array of shapes and values will improve your painting.

Almost every landscape painting is composed of at least two shapes: the sky and the ground.

▷
CALELLA DE PALAFRUGELL, SPAIN
14" × 10" (36cm × 25cm)

This painting can be broken into seven shapes:

sky
background hill
middle ground hill
water
white buildings
foreground wall and shrubs
foreground tree

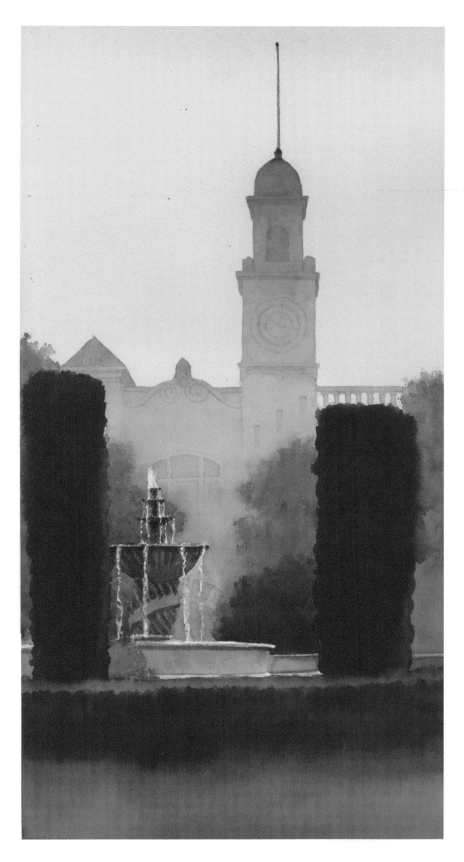

SONOMA PLAZA FOUNTAIN
22" × 11" (56cm × 28cm)
This painting clearly shows seven distinct shapes, each with its own value:

> sky
> background building
> middle ground trees
> fountain
> fountain base
> foreground trees and hedge
> foreground lawn

 Simplifying and arranging shapes are key to a strong composition.

VALUE COMPOSITION:
THE ARRANGEMENT OF SHAPES

Your study sketch is a great tool to use to arrange your shapes and values. I usually start a study sketch with the element that I consider the main subject of the painting. I then add adjacent shapes until I find a pleasing arrangement of varying sizes.

While there is no set formula for the number of shapes, I find that limiting the shapes to no more than nine is a good guideline. It is difficult to ignore objects that are in front of you, such as telephone poles, wires, signs and so on. But if they don't help the composition, they do not need to be included. Or, you can often join them to other shapes, forming one larger shape. Generally, a group of shapes ranging from large to small with a wide range of values leads to dynamic compositions.

Turning the painting upside down helps you to evaluate the shapes, since you're less focused on the subject. Converting it to gray scale makes the value composition much clearer.

▲
FOUNTAIN, ANTALYA, TURKEY
12" × 5" (30 cm × 13cm)
Notice the simplified shapes in this painting. The background is essentially one shape. The middle ground shrubs are simplified shapes as well. The shaded side of the fountain and its ground shadow are combined into one shape. The ability to distill shapes from a complex environment is a strong compositional tool.

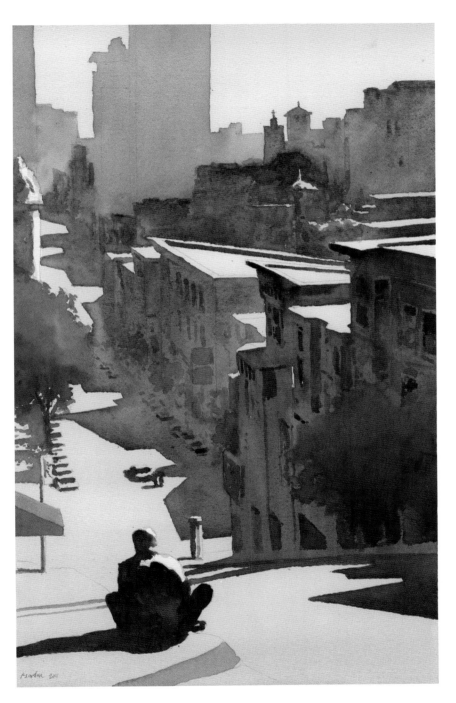

◁

PAINTER ON KEARNY STREET, SAN FRANCISCO
18" × 11" (46cm × 28cm)
This is a studio version of a plein air sketch. Notice the simplified treatment of the cityscape. The background is a simple shape that bleeds into the middle ground, which in turn links to the foreground.

It's also important to remember that the negative shapes, such as the street, rooftops and sky, are also shapes that contribute to your composition. The repeating triangular shapes tie this painting together, echoing the triangular figure in the foreground.

Linking shapes in this way can create a harmonious composition. Even the main figure is linked to the shadow in the foreground. All of the shapes throughout the painting are linked together, unifying the composition.

THE VALUE OF EDGES

Your paintings will benefit from having an assortment of soft and hard edges. Defining some edges crisply while leaving others indistinct creates variety and interest. Soft edges also help you to link shapes. Painting with only hard edges creates a well-defined image. Using both soft and hard edges creates dynamism in your composition.

A painting's visual interest is often due to contrasts, such as sharp value contrast or color contrast. Variation in edge quality is one more tool to use. Softened edges, or leaving the boundaries of objects less distinct, leaves something to the imagination of the viewer and thereby makes a painting more evocative. Leaving some edges soft, while clearly defining the subject with hard edges, is an effective technique to draw the eye to the focal point of the painting.

HARD AND SOFT EDGES

HARD EDGES

SOFT EDGES

A mixture of edge conditions will lend your paintings more visual excitement. Hard edges give definition, while soft edges leave something to the imagination.

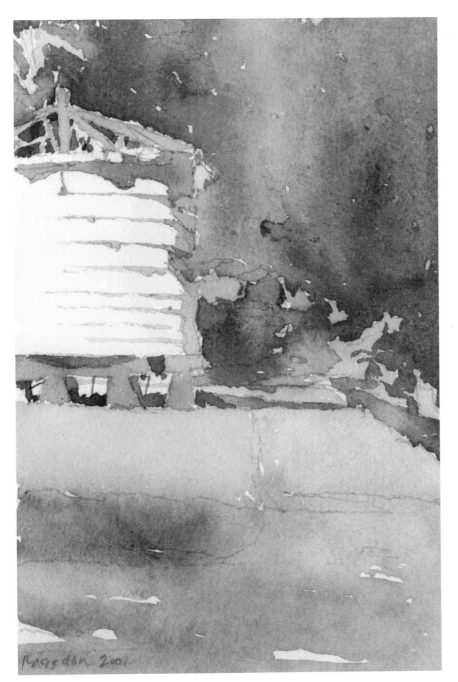

◁

POINT CABRILLO WATER TANK, MENDOCINO

7" × 4½" (18cm × 11cm)

This is a plein air sketch done on a beautiful day in Mendocino. Note how the water tank is composed mostly of hard edges, and the background and foreground areas have mostly soft edges. This is a very effective way to focus the viewer's attention on the main subject of a painting. The overall mix of soft and hard edges adds visual interest. Notice how the soft edges link the major value shapes together, creating a more unified painting.

FOCAL POINT:
THE SPOT OF GREATEST CONTRAST

The viewer's eye will always be drawn to the greatest area of value contrast. This is your focal point. Without a clear place to stop, the eye wanders around a painting aimlessly, without pausing on any specific area due to a lack of a landing spot. If you plan one location with the greatest value contrast—adjacent black-and-white values—the viewer's eye can land on this spot, then begin moving around your painting.

Secondary focal points are value areas that might have a number 10 black but are adjacent to a light area, say a number 3, which is not pure white. The eye will still go there but only after going first to your focal point. You can develop a pathway for the viewer to follow by creating these subsidiary points of focus. All of this can be achieved with a careful value sketch.

MAIN FOCAL POINT

SECONDARY FOCAL POINT

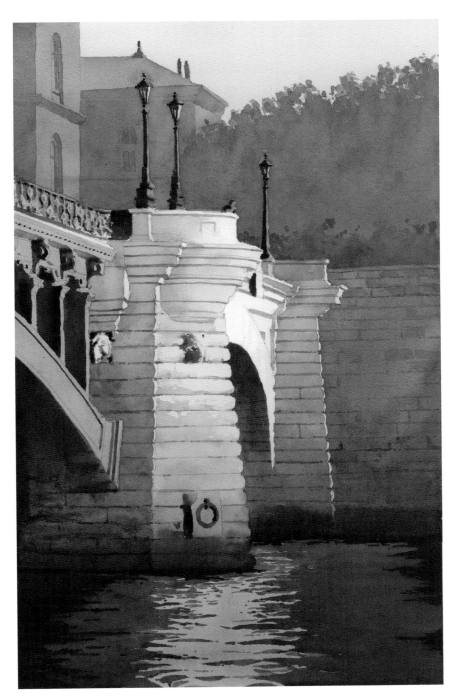

◁

PONT NOTRE-DAME, PARIS
18" × 11" (46cm × 28cm)
This painting has a very clear and
obvious focal point. The top of the arch,
the person at the top of the bridge and
the railing side are the only areas in
the painting where black and white are
juxtaposed.

Secondary focal points, such as the
girder on the left, are areas where black
values are adjacent to values that are
light, but not white. After the eye goes to
the primary focal point, it then goes to
areas such as the green girder.

LIGHT AND SHADOW

In Chapter 4 we discussed the use of light and shadow in architecture. These patterns of light and dark define the architectural subject and imbue it with the ineffable qualities of light. It is through the very careful observation and application of the play of light on surfaces that artists can create paintings of buildings that seem to glow.

The unpainted white of the paper is the source of light in watercolor. Although you can use opaque white paint to retrieve your white areas, the true white of the paper always has a superior glow. It is through the judicious use of whites and almost whites that light is created in a painting.

The use of shadows makes the light sparkle. You need the dark to create the light and vice versa. Careful observation of shadows shows that they are rich in varied colors. Surfaces in shadow reflect the colors around them, such as when ground shadows reflect the sky color or building soffits reflect the ground below them. Don't think of shadows as simply a dark gray value, but as a rich opportunity to use color in your painting.

▷
PIER 7, SAN FRANCISCO
11" × 7" (28cm × 18cm)
The sense of light in this painting comes from the subtle modulation of values. The strongly shaded walkers contrast with the light of the water to the right, imbuing the painting with light. The shimmering use of almost whites delights the eye.

Notice the use of reflected light. The ground plane reflects the sky color, and the reflections mimic the color of the figures.

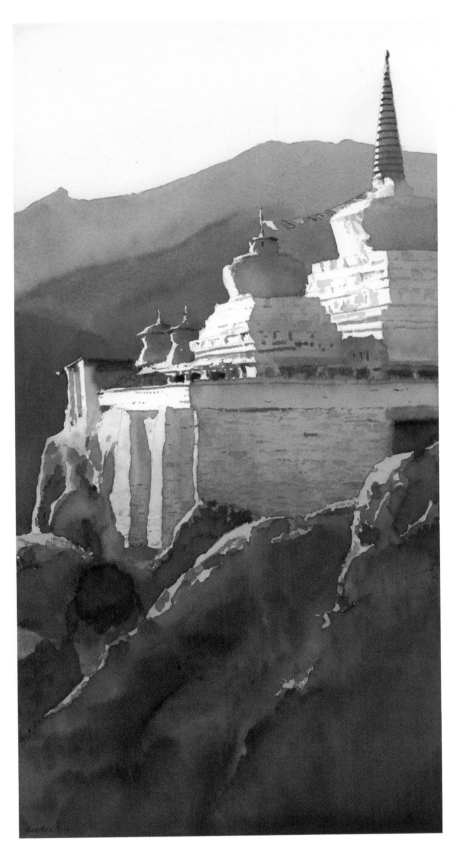

◁
CHORTEN, LAMAYURU, INDIA
22" × 11" (56cm × 28cm)
This painting shows how rich the light can be in a backlit composition. Note how all of the shadow areas are rich medium and dark values. Especially on the chorten itself, you can see the modulations of Cobalt Blue and Cadmium Orange expressing the warm and cool areas of the shaded side.

The shadows are also linked together, simplifying the composition. Note how the background hills melt into the shaded side of the chorten, for example.

One of the best ways for your whites to sparkle is to put them next to an area that is almost white. You can see examples of this in the light areas of this painting. Look for the number 1 and number 2 values in all of the white parts of the painting.

PALACIO REAL DE LA GRANJA, SPAIN

PALETTE

+ Cadmium Orange

+ Cobalt Blue

+ Quinacridone Burnt Orange

+ Viridian

+ Quinacridone Burnt Scarlet

+ Ultramarine Blue

+ Quinacridone Gold

+ Cobalt Turquoise

+ Phthalo Green

REFERENCE PHOTO AND VALUE STUDY

You can see that the reference photo is murky and not terribly interesting. But you can use your imagination and transform it into a painting. It's important to remember that you don't have to copy the photograph.

There are many differences between the photo and the value study. The background buildings are simplified, for example. In the photo, the water cascade is dry, so you can add some water falling down the steps. Most important, you can extend the composition to include the pool of water at the bottom with the reflection of the background buildings.

The photo has supplied the important elements of the scene, but you have the freedom to adjust them to create the painting you desire.

1 THE LINE DRAWING AND UNDERPAINTING

Do a freehand sketch on a piece of 140-lb. cold-press watercolor paper using a soft lead such as a B or 2B pencil. Include only enough information so that you don't spend a lot of time on the drawing but have enough information to use while painting.

After taping the paper to a board, do the underpainting. Start at the top with a diluted wash of Cadmium Orange. Then introduce Cobalt Blue around the buildings. Leave white unpainted paper on much, but not all, of the cascade area, and reintroduce the Cadmium Orange on the grass area surrounding it. Leave most of the walkway unpainted. Then use a mixture of the blue and orange on the rest of the painting, allowing the paints to mingle. In the water at the bottom, reintroduce the Cadmium Orange to reflect the sky color. Let it dry completely.

2 THE BACKGROUND

Using 2% milk washes of Cobalt Blue and Quinacridone Burnt Orange, paint the shade and shadow areas of the background buildings. Leave the lighted areas unpainted. Let the wash blend into the trees. Then use Viridian and Quinacridone Burnt Scarlet to create the grayish green of the trees. Just before the wash is dry, use a brush to drag some of the wash into the sky, softening the edges of the buildings to suggest clouds.

3 THE CASCADE

Drag the moist wash of the building into the cascade using a milk consistency wash of Cobalt Blue. The statuary is indistinct, so indicate the shaded side, leaving the highlights unpainted at the top. Continue the wash into each level of the cascade, leaving some white areas to suggest movement and splashing. Add some Cadmium Orange and Quinacridone Burnt Orange into the water for interest.

Using Viridian and Cadmium Orange, paint the grass area to the right.

While the statuary is still a bit damp, use a creamy mixture of Ultramarine Blue and Quinacridone Burnt Orange to darken the shaded sides of the statuary.

95

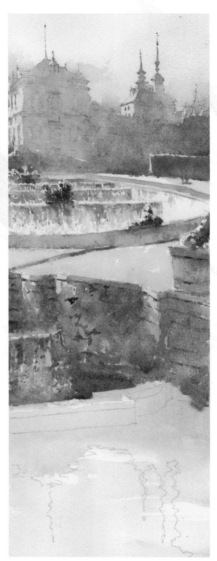

4 MORE MIDDLE GROUND

Using Viridian and Cadmium Orange with a touch of Quinacridone Gold, paint the rest of the surrounding grass area. It's okay to let some of the wet wash on the statuary blend into the grass for a soft edge.

While that area is still a bit damp, paint the rest of the walkway with a non-fat milk mixture of Cadmium Orange, leaving some gaps unpainted for texture. Let that area dry a bit then use Cobalt Blue and Quinacridone Burnt Orange to indicate the curb and step.

5 THE STONE WALL

Using milk and cream mixtures of Cobalt Blue, Cadmium Orange, Quinacridone Burnt Orange and Quinacridone Burnt Scarlet, work wet-in-wet to create a varied texture on the stone wall. As you approach the water, introduce Cobalt Turquoise into the mixture. Use these same colors for the falling water, leaving some unpainted areas to indicate splashing water.

When this area is still a bit damp, use a yogurt consistency mixture of Ultramarine Blue and Quinacridone Burnt Orange to indicate the edges of the stones. Don't overdo it. Paint just enough to indicate their uneven character.

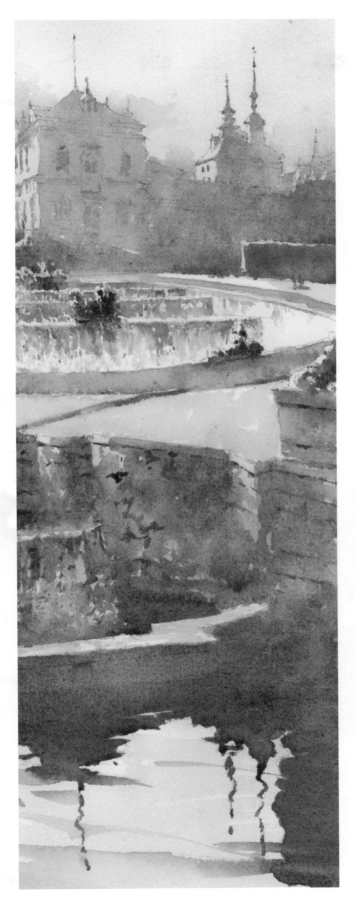

6 THE REFLECTIONS

Blend the foreground wall into the stone wall using a milky mixture of Cobalt Blue. Make a creamy mix of Cobalt Turquoise, Quinacridone Burnt Scarlet and a touch of Phthalo Green and paint the reflections of the buildings in the foreground water. Work quickly and let the Cobalt Blue on the wall blend into the wash, creating a soft edge.

After this wash has dried a bit but is still damp, use big horizontal strokes with your brush to bring some of the reflection wash across the page, indicating ripples in the water.

Note the use of most of the compositional elements discussed in this chapter: a value study, a foreground, middle ground, background, a focal point, simplified shapes, varied edges and a strong sense of light and shadow.

DETAIL

Note the treatment of the water. It isn't pure white but has many other reflected colors in the falling water. The hard and soft edges in the water give the sense of water turbulence and action.

△
**ROMAN ANGEL, PONTE
SANT'ANGELO, ROME**
9" × 4" (23cm × 10cm)
This plein air painting of a sinuous statue
of an angel is composed of four shapes:
the sky, the background, the angel and
the light rectangle in the right corner. The
focal point is the face, where the greatest
value contrast occurs.

Many different colors occur in the
shaded part of the angel, but the value
is the same throughout. You can vary the
color as long as the value is correct.

I find painting "white" objects to be
quite fascinating. The bounced light on
white objects is unsullied by local color,
reflecting the colors that surround it.

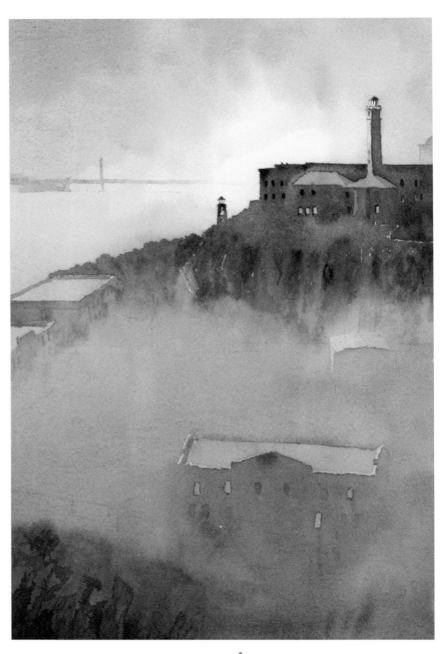

△
**ALCATRAZ NOCTURNE,
SAN FRANCISCO**
14" × 9" (36cm × 23cm)
Notice the careful organization of this
painting. There is an obvious focal
point; a foreground, middle ground,
and background, varied edges, a
strongly backlit subject, and a careful
arrangement of values and shapes.
These are the elements that can lead to
dynamic paintings.

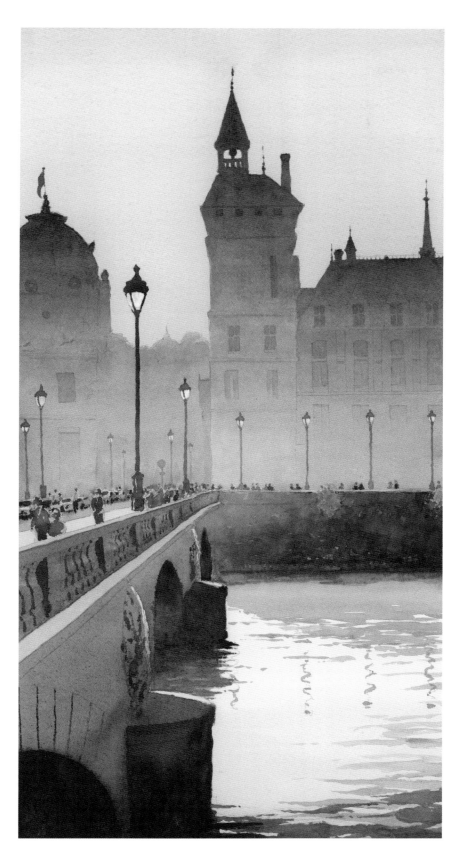

◁

PONT AU CHANGE, PARIS
22" × 11" (56cm × 28cm)
This painting of one of my favorite bridges in Paris is a clear example of simplified shapes. Notice how all of the background buildings are linked, forming a single shape. The middle ground embankment is a single value, seamlessly connecting to the bridge, again yielding a simplified shape.

 Distilling a complicated scene into a few shapes is one of the keys to successful composition. Details, such as the lampposts, add character but will rarely save a poorly composed painting.

◆

Often, less is more. It isn't necessary to show everything. Implication leaves something to the viewer's imagination.

◆

7

COLOR IN THE ARCHITECTURAL LANDSCAPE

If values play the lead role in representational painting, then color wins best supporting actor. Values, while quite compositionally powerful, can lack emotional spark. Color, with its visceral appeal, expands the power of values to make paintings that entice. Painting architecture and landscape presents unique challenges and opportunities. By using complementary colors, you can make your buildings glow. By exploiting the idiosyncrasies of pigments, you can create luscious greens, brilliant shades of white and rich darks, all of which are critical to architectural settings.

◁
MAGGIORE
Detail

COMPLEMENTARY COLORS

As pointed out in the preceding chapters, using contrasting values crafts strong watercolor compositions. Similarly, color contrast—the juxtaposition of complementary colors—can ignite the colors in a painting.

There are many uses for complementary colors. A touch of red in a field of green makes the green seem more vibrant. Cool blue shadows adjacent to orange tile roofs make the oranges sparkle. Purple shadows on golden hills vibrate. Complementary colors are a powerful tool for you to use to make your colors shimmer.

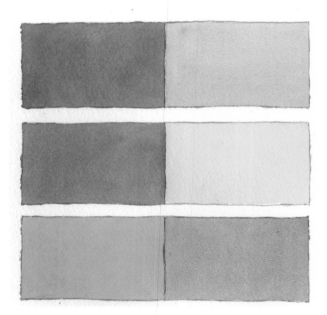

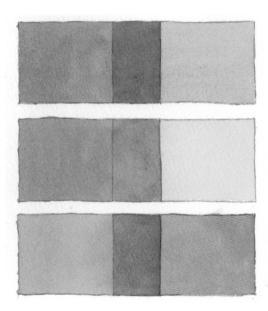

THE BASIC COMPLEMENTS

Complementary colors are the opposites of each other. As a result, when placed side by side, they cause each color to seem more intense.

Blue and Orange
Purple and Yellow
Green and Red

Place your finger over one of the colors and judge the color. Remove your finger and see how the color is more intense when paired with its complement.

COMPLEMENTARY GRAYS

Mixing all three primaries makes gray or black. For example, when orange is added to blue, you have two primaries in orange—red and yellow—plus the third primary, blue, which makes gray. A more creamy mixture of these complements makes black.

The same holds true for purple (blue and red) plus yellow, as well as green (blue and yellow) plus red.

△
SOROLLA'S GARDEN, MADRID
14" × 6" (36cm × 15cm)
The colors in this painting are a clear
example of the visual excitement
generated by juxtaposing complements.
Blues next to oranges and reds
next to greens are used throughout.
Complementary colors are the secret
ingredient for enlivening your paintings.

△
HERVAS, SPAIN
14" × 9" (36cm × 23cm)
Note the prevalence of the complements of blue
and orange in this painting. The bluish shades and
shadows next to the orange tile roofs make both
colors seem more intense.

Similarly, the foliage is a mixture of green pig-
ments plus their complement, red (and orange). If
you look closely you can see the reds and oranges
poking through the wet-in-wet mixture, making the
greens shimmer.

The grays are primarily a mixture of the same
blues and oranges used throughout the painting.

LUSCIOUS GREENS

Greens are notoriously one of the most difficult colors in watercolor and one of the most important in landscape painting. Yes, you can mix blue and yellow to make green. For example, Cerulean Blue—a slightly greenish shade of blue—combined with yellows and oranges can yield pleasant shades of green.

Yet such green mixtures can easily appear lifeless. By using blue and yellow, you already have two pigments in your mixture. Add two more and you are on the edge of muddiness.

I choose to start with pure green pigments (single pigment colors). I then have the flexibility to add up to two more pigments to create a large array of unsullied shades of green. Plus, my two go-to greens, Viridian and Phthalo Green-Yellow Shade, are quite transparent, thus enhancing the brilliance of the greens.

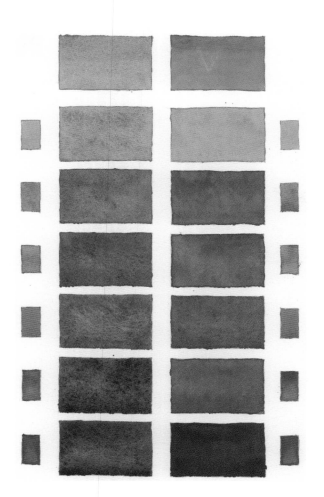

VIRIDIAN MIXED WITH (FROM TOP TO BOTTOM):

Quinacridone Gold

Quinacridone Burnt Orange

Quinacridone Burnt Scarlet

Cadmium Red

Quinacridone Rose

Carmine

PHTHALO GREEN-YELLOW SHADE MIXED WITH (FROM TOP TO BOTTOM):

Quinacridone Gold

Quinacridone Burnt Orange

Quinacridone Burnt Scarlet

Cadmium Red

Quinacridone Rose

Carmine

The color chart shows my favorite green mixtures.

As you can see, mixing Quinacridone Gold with either of my go-to green pigments yields yellowish grass greens. Adding red or orange to the pigments yields grayer greens, usually appropriate for trees and shrubs.

Viridian is a very weak color. Just a bit of another pigment will change its hue. I use Viridian for light-valued areas, such as grass. On the other hand, Phthalo Green is a very strong pigment. You'll need to add a large proportion of another pigment to change its hue. Due to this strength, it can generate very dark-valued greens.

Many other pure green pigments can also be used as your base green, such as Amazonite, Jadeite, Chromium Green Oxide and Perylene. All can produce distinctive shades of green. It is worthwhile experimenting. Whichever green pigment you choose, make sure it isn't pre-mixed, such as Sap Green, because then you run the risk of muddiness if you add another color. I have found that Viridian and Phthalo Green-Yellow Shade create most of the greens I need.

VILLAGE OF SANTIAGO, GUATEMALA
10" × 5" (25cm × 13cm)
Phthalo Green-based mixtures predominate in the hillside areas of this painting. Note how the reds and oranges show through, making their complement, the greens, seem more vibrant. For the green water, I used a bit of Cobalt Turquoise to add a shade of blue-green to the color. Since the total number of pigments is only three, the color remains unsullied.

HAMMOCK, CIRALI, TURKEY
9" × 6" (23cm × 15cm)
Most of the shades of green in this painting are Phthalo Green mixtures, including the large grass area. Compare these greens with the table on the opposite page and you can clearly see how they were mixed.

Keep in mind that using Phthalo Green takes some getting used to. The pigment's intensity can overwhelm other pigments. You have to add a lot of orange or red to counteract its strength and produce more natural-looking greens. Don't give up the first time!

SHADES OF WHITE

In watercolor, the purest and brightest white is the white of the paper. By not applying paint, you create pure white, the source of light in your painting.

Preserving these white unpainted areas is paramount in most watercolor compositions. As mentioned in the chapters about values, focal points are areas that have the greatest value contrast—your darkest dark against your whitest white. Juxtaposing an unpainted white with black is the best way to demarcate a focal point.

White objects are rarely pure white. Most times they are "almost white," a highly thinned non-fat milk mixture of pigment and water. For example, a diluted wash of Cobalt Blue makes a cool shade of white, while a similar mixture of Cadmium Orange yields a warm shade. These watery washes slightly tint the paper, yet they still look white when placed against a darker value.

COBALT BLUE

CADMIUM ORANGE

CADMIUM YELLOW

QUINACRIDONE ROSE

VIRIDIAN

EXAMPLES OF "ALMOST WHITES"

The painting of the white chair on the opposite page demonstrates how "almost whites" appear white when placed next to a darker value.

White objects in particular offer many opportunities to paint reflected or bounced light. When you carefully observe a white object, you can see the sky color, for example, reflected on the surfaces that face the sky. Similarly, the greens in the landscape and the ground color are bounced off the object, leaving their "almost white" tint on the surface.

Somewhat counterintuitively, an "almost white" placed next to a pure white makes the pure white seem whiter than black does.

LEH PALACE, LADAKH, INDIA
22" × 11" (56cm × 28cm)
White areas are compositionally magnetic, drawing the viewer's eye. They must be used judiciously and placed where you want attention. Note also how the pure white seems whiter because of the adjacent "almost whites."

LA CHAISE BLANCHE, SARLAT, FRANCE
9" × 5" (23cm × 13cm)
White objects are one of my favorite watercolor subjects. I find the play of bounced and reflected light fascinating. Observe the various shades of white on this white chair, particularly the shifts of warm and cool tones. Even though these shades are not pure white, they still read white.

SHADES OF GRAY

When I was learning watercolor, one of the most befuddling aspects of the medium was how to make darks. When teaching today, I often see students facing the same predicament. Yet using dark colors adds to your value range, increases the depth of your paintings and augments your painting repertoire.

The only way to make watercolors dark is by using very little water in your painting mixtures. But, as we noted in Chapter 5, combining dark-valued pigments is the only way to produce dark values. Remember, not all pigments yield a large value range, and those that don't will never produce a dark color.

It can be scary to use such heavy pigment. I often suggest that students experiment with undiluted washes, almost straight out of the tube, to see how much pigment is necessary to make dark colors. Once seen, they better understand the pigment-to-water ratio required to make darks and can adjust accordingly.

I generally avoid using pre-mixed blacks. They tend to be opaque and can become chalky. The exception is Neutral Tint. Nonetheless, I suggest you avoid using it and concentrate instead on making your own blacks. Neutral Tint can be useful at times but can also overwhelm many colors if overused. However, there are times when it can be helpful if you need a very dark black very quickly.

BLACKS

These two color combinations create a rich black.

By emphasizing either the cool or the warm color, you can mix a warm or cool black. The secret is to use a thick mixture of paint. Think Greek yogurt.

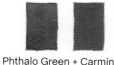

Phthalo Green + Carmine =

Ultramarine Blue + Quinacridone Burnt Orange =

GRAYS

Cobalt Blue is a great gray mixer. Cobalt Blue has a medium value range and will always create gray, even at full strength. It can be mixed with complementary shades of orange to create a myriad of gray shades.

Cobalt Blue + Cadmium Orange =

Ultramarine Blue + Burnt Sienna =

SHADOWS

These color combinations have served me well over the years for architectural subjects.

Like blacks, you can create warm and cool shadows by emphasizing either the warm or cool pigments. Most of the time a gradated wash of each color works best.

Cobalt Blue + Quinacridone Burnt Scarlet =

Ultramarine Blue + Cadmium Orange =

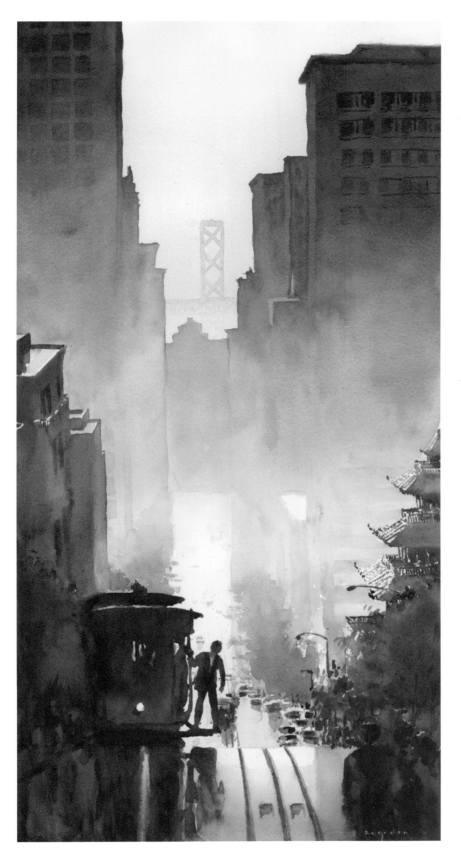

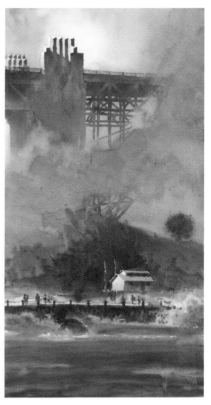

△

SOUTH ANCHORAGE, GOLDEN GATE BRIDGE
28" × 14" (71cm × 36cm)
In both of these paintings, note the deep blacks and the myriad shades of gray throughout. The blacks were sometimes created using the Phthalo Green/ Carmine mixture. A bit of Neutral Tint was added for the deepest black. A mixture of Ultramarine Blue and Quinacridone Burnt Orange combined for other blacks. The grays mostly comprise Cobalt Blue mixed with Quinacridone Burnt Scarlet or Quinacridone Burnt Orange.

◁

CALIFORNIA STREET, SAN FRANCISCO
28" × 14" (71cm × 36cm)

VENETIAN CANAL

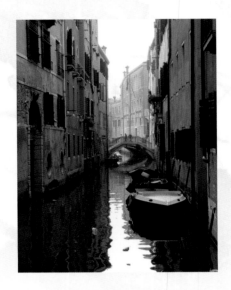

PALETTE

+ Cadmium Orange

+ Cobalt Blue

+ Cadmium Yellow

+ Quinacridone Burnt Orange

+ Quinacridone Burnt Sienna

+ Ultramarine Blue

+ Cadmium Red

+ Cobalt Turquoise

+ Phthalo Green-Yellow Shade

+ Carmine

+ Quinacridone Burnt Scarlet

+ Viridian

REFERENCE PHOTO

This photo has many attributes that contribute to a strong composition: a singular focal point and a clear foreground, middle ground and background.

1 THE VALUE SKETCH

Since the horizon line of the photo is near the middle of the picture, making the background and sky equal in size to the water, extend the bottom of the painting to show more of the water. Doing so also accentuates the narrowness of the canal. Crop the left side so that the canal is off center.

Change the direction of the light source so that it comes from the upper left, permitting the buildings on the right side of the canal to be illuminated while the left is in shadow.

Note the light value of the background, exaggerating the mistiness of the scene.

Animate the scene with a figure on the bridge and one in the boat at middle-ground.

2 THE LINE WORK

Using a soft pencil, transfer the value study to 140 lb. cold-press watercolor paper. Simplify the architectural elements, treating them as shapes.

Since the water is very important, carefully indicate the reflection pattern, especially around the boat, which is your focal point. Be sure the reflections mirror the buildings, boats and bridge. If they don't echo what is above, the reflections won't make a lot of sense.

3 THE UNDERPAINTING

Starting at the top with a diluted mix of Cadmium Orange, begin a gradated wash to indicate a warm pale sky. As you reach the lower part of the buildings, introduce Cobalt Blue to indicate that the warm light is only hitting the tops of the buildings. When you reach the boats, clean your brush and use pure water, letting the white of the paper show through. Just past the closest boat, introduce a diluted mixture of Cadmium Yellow and then reintroduce the Cadmium Orange, reflecting the warm sky. Finish off with Cobalt Blue at the bottom. As the reflections get closer to you, you see less of the reflection and more of the transparency of the water.

4 THE SUNLIT SIDE

Using a stronger mixture of Cadmium Orange mixed with Quinacridone Burnt Orange, lay a wash over the sunlit areas of the buildings. Note that the background wash is a shade darker than the sky. Continue down toward the water, mixing Cobalt Blue into the wash. Don't be afraid to make the wash irregular. The buildings have a lot of character and shouldn't be too smooth.

As this wash begins to dry, introduce the building elements. Cobalt Blue grayed with a bit of Cadmium Orange is used for the background details. For the middle ground details, create grays and blacks, mostly Cobalt Blue and Quinacridone Burnt Sienna, and use Ultramarine Blue with the Burnt Sienna for the darker grays and blacks. There is a bit of Cadmium Red in the flowers on the upper balcony.

For the light water reflection from the bridge, use a bit of Cobalt Turquoise and Quinacridone Burnt Orange.

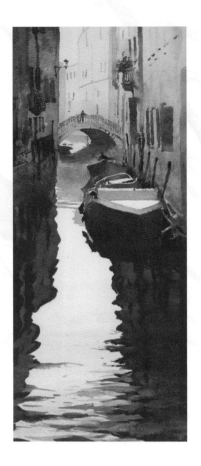

5 THE BOATS AND REFLECTIONS

Link the dark building washes into the dark areas of the boats, carefully leaving the white highlights unpainted. Use some Cadmium Red on the second boat, and Cobalt Blue and Cobalt Turquoise for the foreground boat's lighter-valued areas.

Mix a creamy wash of Ultramarine Blue and Quinacridone Burnt Orange for the very dark area of the foreground boat. At the same time, mix a creamy mix of Phthalo Green, Carmine and Cobalt Turquoise. Starting at the top of the boat, use the blue-black mixture. At the waterline introduce the green-black mixture, tying it into the dark areas in the building. Continue this wash into the darkest areas of the reflections, linking all of the various shapes together, all the way to the bottom of the page.

Let it dry almost completely, then mix a lighter green-black wash of Cobalt Turquoise and Quinacridone Burnt Scarlet and glaze over the whole reflection, paying close attention to the wavy pattern of the reflected edge. As you reach the bottom, indicate some rough waves, using both the dark and light green-black mixtures.

6 THE SHADED SIDE

The shaded side on the left is painted much like the sunlit side, only the washes are a bit heavier to make them darker. Use some of the warmer tones near the middle, reflecting the warm light from the other side. When partly dry, but still damp, use a black mixture of Ultramarine Blue and Quinacridone Burnt Orange for the very dark details.

At the waterline use the same process you used in Step 5 to link the dark areas. Use a very dark green-black that is glazed with a lighter green-black when the wash is almost dry. Be sure to blend this mixture into the bottom of the building.

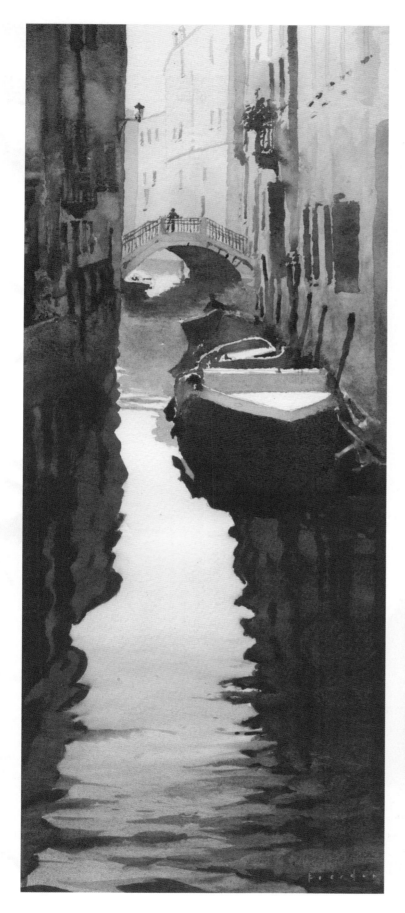

7 FINAL TOUCHES

This is an optional step. I usually stop at this point of a painting, but my underpainting wash was too light, so I felt it was important to make a slight adjustment. I decided to darken the value of the reflected light area in the water. Be careful when making such final alterations. It is very easy to overwork a painting in the final stages.

Using light washes of Cadmium Yellow, Cadmium Orange, Viridian and Cobalt Blue, glaze a graded wash starting with clear water near the foreground boat, introducing the other colors as you move down the page. Be careful of the dark reflected edges since the heavy pigments will bleed if you touch them.

---◆---

Many pigments were used in this painting, yet the color composition remains harmonious. The brightest colors were used near the focal point, nowhere else.

---◆---

DETAIL

Note how the dark wash starts from the top of the boat and runs into the reflection, changing hue but not value. It isn't necessary to have a hard line between the object and the reflection.

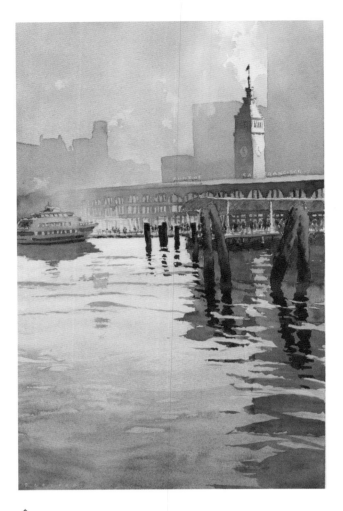

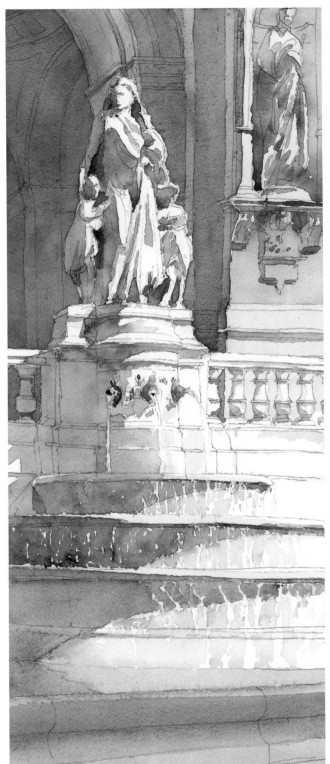

FERRY LANDING, SAN FRANCISCO
14" × 9" (36cm × 23cm)
By juxtaposing soft and varied grays, bright colors stand out even more. The gray versus bright contrast is a compositional tool that's similar to the other sources of contrast discussed earlier.

▷
FONTAINE DE LA TRINITÉ, PARIS
14" × 6" (36cm × 15cm)
The use of complementary colors makes the colors in this painting seem quite colorful. Colorful paintings don't necessarily use a lot of different colors. Complementary colors vibrate when juxtaposed and seem much brighter and dynamic as a result. Throughout this painting you see blues paired with oranges, greens near reds, and purples next to yellow-oranges. Employing these color opposites will make your colors appear rich and vivid.

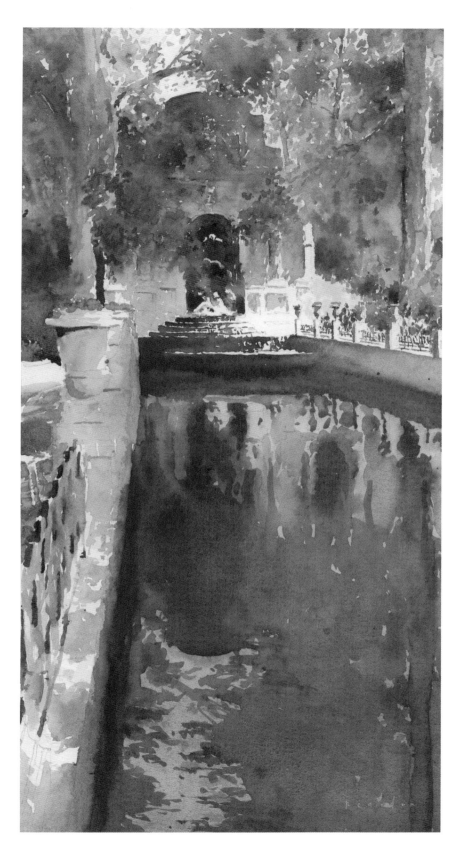

◁
FONTAINE DES MÉDIÇIS, PARIS
20" × 10" (51cm × 25cm)
This painting is an example of the great variety of green shades that can be mixed using Viridian and Phthalo Green-Yellow Shade as the base. All of the greens are made from those two pigments, with a bit of Cobalt Turquoise in the water.

Letting some of the complementary oranges that were mixed with these green pigments show through adds visual excitement. Note also the yellow shrub next to the purplish monument; this is the only place in the entire painting where these complements are adjacent, making the area stand out. Adding these places of complementary color makes the painting look richer. Look carefully at many Impressionist paintings. A green field often has a smattering of red. Purplish shadows sometimes are enhanced with yellow-orange. A white dress will have blue and orange shadows. Artists have used complements for centuries. While complements can be overused, their deft use is a powerful tool for developing vibrant color.

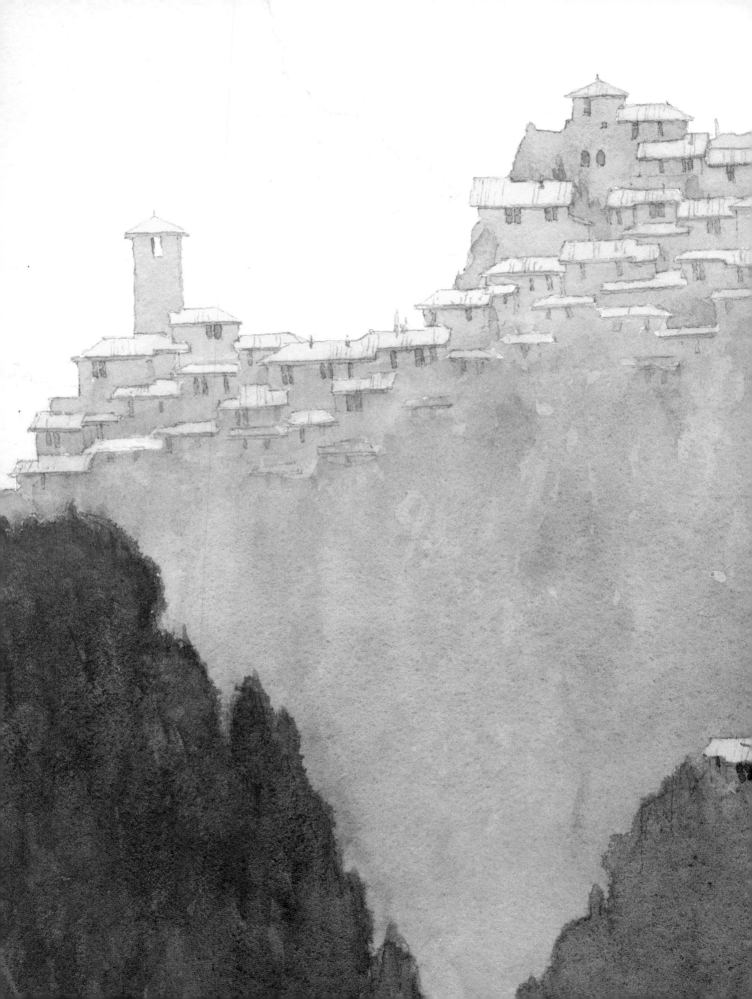

8

THE ALLURE OF COLOR

———————◆———————

Color affects viewers subliminally, shaping the mood and atmosphere of any painting. Not only do specific hues arouse certain emotions, but their brightness, dullness, coolness or warmth influence a viewer's response to your work.

A riot of color incites excitement. Cool, subtle grays suggest a feeling of quiet. Color, perhaps more than value, lends feeling to a watercolor painting. This emotional aspect of color can set an evocative painting apart from a merely descriptive one.

Everyone enjoys color. Going into the watercolor section of an art supply store can be like visiting a candy store. All of those alluring colors are tantalizing. It's worthwhile, however, to think beyond the specific colors and to choose colors for the affect they will have on the viewer.

ISEO
Detail

COLOR AND MOOD

Color generates an emotional response from the viewer. Red, more often than not, triggers feelings of excitement and passion. Blues often prompt a sense of calm. White can evoke purity and light.

Colors also have cultural symbolism. Green, for example, signifies environmental awareness. A universal color code, however, is problematic. Studies show that color affects people in different ways, especially across cultures.

Nevertheless, your color choices do have an effect on the viewer. If you are trying to evoke a feeling of tranquility, for example, a riot of bright colors in the sky probably isn't a good choice; a soft blue-gray sky would probably work better. Awareness of the power of color when composing a painting will help you convey the feeling you hope to suggest.

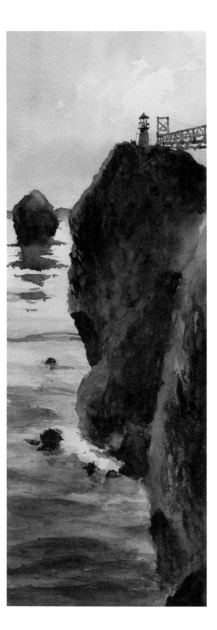
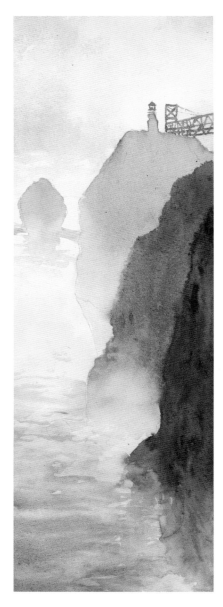

▷

POINT BONITA LIGHTHOUSE
18" × 6" (46cm × 15cm)
The subject and composition of these two paintings are almost identical. Only the color palette is altered. While the skies are similar, all the other colors vary. The mood of each painting is considerably different.

The painting on the left is very literal; it uses colors that are truer to the actual scene. On the right, the treatment is mistier and less distinct; the bluish cast changes the feeling of the landscape. Clearly, your color choices can alter the impression your paintings make. I did the version on the left first but felt that it lacked emotional impact. So I changed the color palette to evoke a tranquil atmosphere and add some mystery to the scene. You don't need to use realistic colors if other colors will work better to suggest the mood you wish to express.

◁

**LAMAYURU MONASTERY,
LADAKH, INDIA**

22" × 11" (56cm × 28cm)

This is a case in which red has religious symbolism. Buddhist monasteries and spiritual locations in the Himalayas use a red marker to indicate they are a religious structure. Awareness of color symbolism is important to keep in mind, especially when painting subjects from other cultures.

Nonetheless, it is necessary to differentiate between symbolism and mood. In this painting reds and oranges predominate, suggesting a warm late afternoon. Imagine the difference in feeling if the painting was blue and misty, such as with the painting of *Point Bonita Lighthouse* on the opposite page. Color choices can have a profound effect on the impact of your work.

CHROMA AND COLOR

Chroma, the relative intensity or brightness of a color, influences the mood of a painting. A bright orange, for example, will scream for attention while a diluted orange will whisper a warm tone. Red and pink, although the same hue, have a very different impact in a painting. The same holds true for deep violet and pale lavender, or deep ultramarine and sky blue, or forest green and soft viridian.

Generally, a painting composed of intense colors has a very different feel than one of subdued colors. Using intense colors to focus attention in a painting while muting colors in less important areas is a very effective compositional tool.

Creating areas of contrast between bright and pale colors, just like white and almost white, will make the bright areas seem brighter and the pale areas paler. Chroma is one more source of contrast you can use in your paintings.

Bright colors shout. Subdued colors whisper.

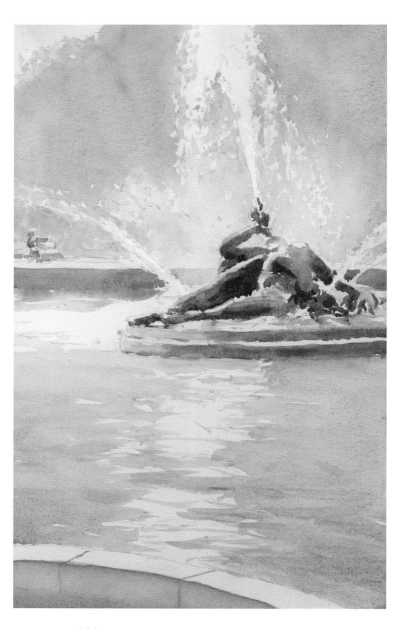

▷

FONTAINE DE VAUX-LE-VICOMTE
14" × 9" (36cm × 23cm)
Most of the colors in this painting are quiet and restrained. Notice that the brightest color is the water and even it isn't terribly bright. By graying down the other hues, the blue of the water stands out, helping to draw the eye to the focal point.

Playing down the overall chroma of the painting accentuates the misty feeling. Since the fountain sculpture doesn't have much local color, the other colors are muted so they don't compete.

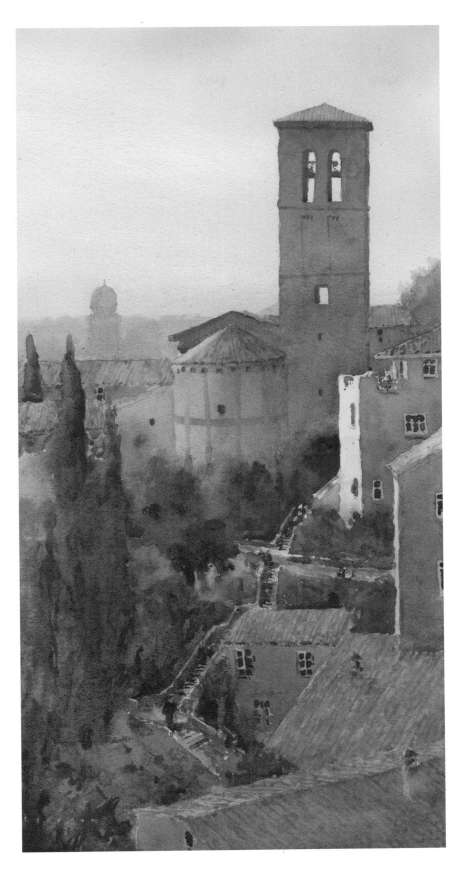

ABBAZIA DE SAN PIETRO, ASSISI
20" × 10" (51cm × 25cm)

I tend to prefer colors that are subdued. This is strictly a personal preference. Because of this, I generally don't use highly chromatic color, favoring hues that are more muted.

None of the hues in this painting are colors right out of the tube; all have been mixed. For example, the orange roofs are toned down and the greens are grayed, contributing to a contemplative mood rather than a brightly colored, festive atmosphere.

Note also the use of complementary colors. Again, all of these complements are not pure but have been blended in order to mute their intensity. To create the vibrancy of complementary colors, it isn't necessary to use pure colors. Subtle mixes can be just as effective and have the extra benefit of suggesting a feeling of tranquility.

WARMS AND COOLS

The contrast of cool and warm colors is another way to add excitement to your painting. Throughout this book I have talked about various contrasts: values, complementary colors, edges and chroma, to name a few. Color temperature is one of the most effective and underrated sources of contrast.

In architectural work, a warm orange and a cool blue are a classic combination, indicating a warm sunlit object and a cool shadow. Purple (cool) and yellow (warm) work in a similar fashion. For obvious reasons, red and green aren't quite suitable for most buildings, although they are quite exciting when used in foliage and landscape paintings. These color combinations are also complementary, providing a source of visual vibrancy.

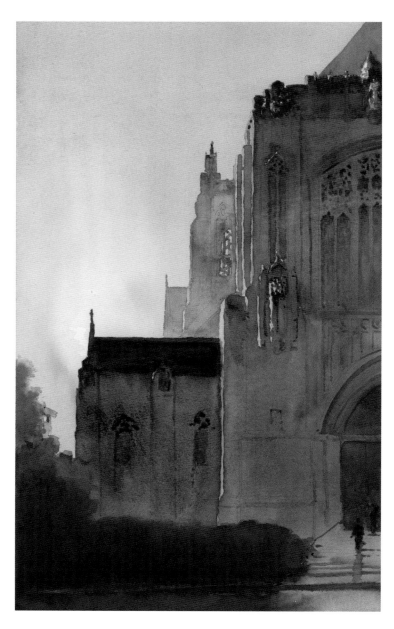

COLOR TEMPERATURE

Every color has a temperature: warm or cool. Generally the warm colors tend toward red and yellow and the cool colors toward blue. Orange is almost always warm, since it is a combination of the two warm primaries, red and yellow. Green and violet can go both ways depending on the amount of cool blue. Of course, there are cool reds and warm blues, but a cool red is still warmer than a cool blue and vice versa.

SS. PETER AND PAUL, SAN FRANCISCO

28" × 18" (71cm × 46cm)

This painting is made primarily with only four colors: Cadmium Orange and Quinacridone Burnt Scarlet for the warm colors, and Cobalt Blue and Ultramarine Blue for the cool colors.

Note how the upper part of the church has a blue cast, reflecting the blue sky. The lower half transitions to orange, reflecting the warmth of the ground. Similarly, the parts of the church that face toward the ground, such as the soffits, are the warm orange, while the shadow areas on the surface are the blue of the sky.

Limiting your palette to a few warm and cool colors provides many opportunities for temperature contrast while preserving color harmony.

SAINT DOMINIC'S, SAN FRANCISCO

18" × 11" (46cm × 28cm)

This painting employs a classic warm and cool composition. The sky area and sunlit sides are predominantly warm, and the backlit church is mostly cool. Within each area the complementary warm or cool color adds visual interest and emphasis.

COLOR AND COMPOSITION

The use of color in composition is as fundamental to watercolor painting as the other compositional elements covered so far, such as focal point, value grouping, foreground, middle ground, and background. The contrast of color temperature and complementary colors has a profound effect on how your painting is perceived.

I shy away from hard-and-fast rules about composition. There are many of them. There is, however, a general rule about color and composition that is quite valid: A dominant color makes your painting more cohesive. Choosing one color that appears in most of your mixtures will link the colors together, leading to a more harmonious painting.

Consequently, a color that is the complement of your dominant color will stand out as an accent. There are certainly exceptions to this rule, but look at the images in this book and you will see this convention used quite often. Be careful not to place accents everywhere however. They do attract attention and are better placed near the focal point or other areas of importance.

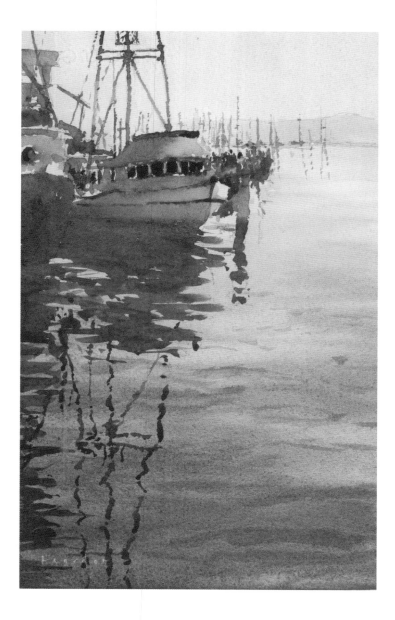

A dominant color ties a painting together. A painting with a dominant color is more homogeneous and harmonious.

◁
THE WHARF, SAN FRANCISCO
10" x 6" (25cm × 15cm)
A dominant color, Cobalt Blue, is present in almost all of the color mixtures and yields an overall cool temperature. Near the focal point, some warm and intense Cadmium Red and Orange are introduced as accent colors, reinforcing the focal point created by value contrast.

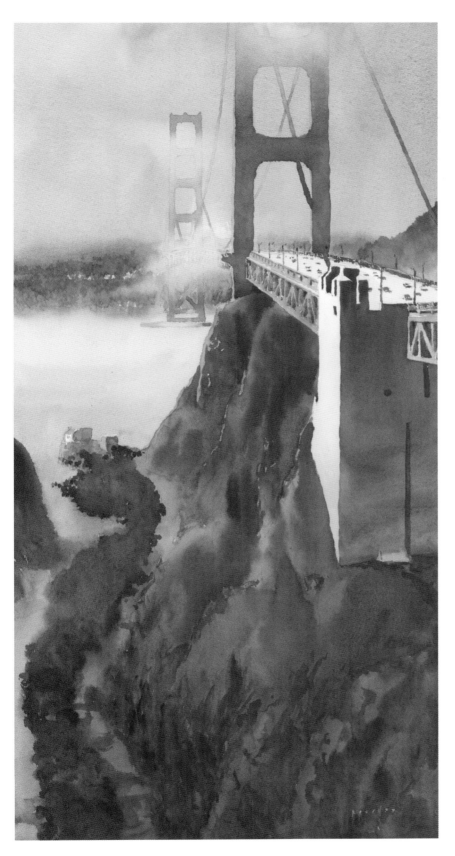

NORTH ANCHORAGE, GOLDEN GATE BRIDGE

28" × 14" (71cm × 36cm)

This painting has a yin and yang color temperature composition: the cool sky and water on one side, and the warm bridge and hillside on the other. This color device emphasizes the strong diagonal of the hillside, which further strengthens the composition.

The accent color, Cadmium Orange, works with the contrast of values to lead the eye toward the focal point, the bridge's buttress. Because it is a complement to the blue, the orange sparkles around the area of greatest interest.

KNOWING YOUR COLORS

Every pigment interacts differently with other pigments. Often it's due to many of the pigment qualities discussed earlier in this book, such as transparency, opacity or staining and non-staining. Many times it's because some colors blend particularly well with other pigments. Intuitively knowing how pigments work together will increase your confidence, usually leading to a more satisfying painting experience.

This knowledge can only be acquired by painting every chance you get. Experimentation is the only way to know how colors will behave. When I was learning, I made a chart of all of the colors on my palette, from a full-strength yogurt mixture to a weak non-fat milk mixture. I put this on my bulletin board and referred to it when deciding which color to use. Eventually the qualities of these colors cemented in my brain and became second nature. If you aren't yet sure of your colors, such a chart is a useful exercise and will help you to fully understand your pigments.

The only way to fully understand your pigments and how they interact is to paint at every opportunity you get.

◁

FONTAINE DU THÉÂTRE FRANÇAIS, PARIS
14" × 7" (36cm × 18cm)
When I was awarded the Gabriel Prize to paint for three months in Paris, I took the opportunity to experiment with various color mixtures. One of my favorites, Cerulean Blue, Cobalt Violet and Viridian, can be seen in the background of this painting. By mixing these three colors on the paper rather than on the palette, they intermingle and granulate to create an intriguing misty background. This is the kind of color knowledge that you can develop as you experiment for yourself.

HEMIS MONASTERY, LADAKH, INDIA
11" × 5" (28cm × 13cm)

I have kept the same basic colors on my palette for a very long time. I occasionally experiment with other colors, but there are fifteen or so pigments that are my mainstays. Because I know them so well, I know with some certainty how they will behave on the paper.

It takes some time to get this comfortable with your palette. If you haven't painted much, of course you need to experiment with colors to find the palette that works for you. In the end, you really only need a few blues and oranges, a couple of reds and greens, and one or two yellows. Keeping your palette limited will ensure color harmony and help you to develop an intuitive knowledge of your pigments and how they work together.

This painting was completed plein air in about forty-five minutes. Thoroughly knowing your palette facilitates working quickly, because you don't have to spend much time thinking about which color to use. Working quickly and finishing a piece all in one go keeps your paintings looking fresh and not overworked. An added benefit is that you can still get up after sitting on the ground, as I did here.

BLUE MOSQUE, ISTANBUL

REFERENCE PHOTO

This photo was taken from the middle of a busy street. I was enamored with the strong silhouette of the backlit mosque and thought it might make a good painting. The whizzing traffic precluded a plein air sketch as an option, making this photo the only possible reference.

The photo has limited value to compose a painting. Few building details are visible and a billboard obscures much of the lower part of the building. Since the photo is so compromised, a literal copy would likely lead to an unsatisfying painting.

However the photo has many promising aspects, particularly the striking silhouette of the mosque. Some imagination and invention is needed to fill in the details.

PALETTE

+ Manganese Blue
+ Quinacridone Rose
+ Cadmium Orange
+ Cobalt Blue
+ Ultramarine Blue
+ Quinacridone Burnt Scarlet
+ Carmine
+ Phthalo Green-Yellow Shade

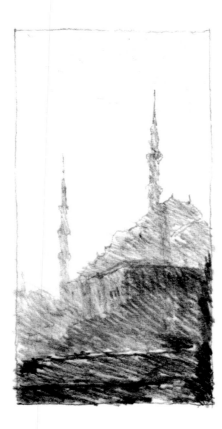

1 THE VALUE STUDY

Use a value study to explore ways to improve the photo image. Make the upper part of the mosque the background; an invented building and garden the middle ground; and a piece of another building and cypress tree the foreground. Exaggerate the value range of each area, from a light background to a dark foreground, to create a sense of depth.

Since they are invented, feel free to alter the middle ground and foreground buildings. They set the stage for the strong building silhouette in the background.

Crop the image to place the main dome off center.

2 THE PENCIL LINE DRAWING

Using a soft 2B lead on Arches 140-lb. cold-press watercolor paper, do a line drawing of the image. It isn't important to draw every detail. Try to get the larger shapes delineated. You can add fine details as you paint.

3 THE UNDERPAINTING

Tape your paper to a board, preferably with a good quality masking tape.

Do a gradated wash down the entire sheet of paper. Start your wash at the top with a non-fat milk consistency wash of Manganese Blue. Manganese Blue is a very weak pigment, so you have to mix a lot of pigment to make this wash dark enough. As you approach the top of the minarets, rinse your brush and blend the blue into clear water, suggesting misty clouds with the pure white of the paper. Continue the wash down the paper using a very light wash of Quinacridone Rose, followed by Cadmium Orange and then Cobalt Blue at the horizon. Return to the Cadmium Orange all the way to the bottom of the page.

Remember to use horizontal strokes with your board at a slant and to keep the wash continuous. The only white unpainted paper is the misty cloud near the top of the minarets.

4 FROM THE TOP

Painting the background mosque will work best if you try to do it all in one go. Pre-mix Cobalt Blue, Cadmium Orange and Ultramarine Blue into separate puddles. Do not mix them together. Make them fairly thick washes, like cream. You can always add more water if needed.

Starting at the highest minaret, use Ultramarine Blue at the top and introduce Cobalt Blue as you go down. Ultramarine Blue is a darker blue than Cobalt Blue and will create a slightly darker value at the top.

5 THE BACKGROUND

For the entire background area, use Cobalt Blue and Cadmium Orange. Continue the wash down the page, introducing the Cadmium Orange on the undersides of the protrusions of the minarets, as if they are reflecting the warm colors from the ground.

Link the minarets into the Cobalt Blue dome, then warm the wash with Cadmium Orange as you reach the bottom of this area. Do the second minaret in a similar manner, making the wash a bit more diluted so the minaret is lighter in value to accentuate the illusion that it is receding.

Continue the wash over the entire background, intermixing the Cadmium Orange and Cobalt Blue. Try to mix them on the paper, not your palette.

6 THE MIDDLE GROUND

Continue the background wash into the distant trees and tower. Then, using a very creamy mix of Ultramarine Blue with a bit of Quinacridone Burnt Scarlet, paint the roof of the middle building. Using thicker washes than you used for the background—a cream consistency—paint the rest of the building, mixing the same two colors plus Cadmium Orange for the building and the tree area below. Note that it isn't necessary to paint the trees green.

Think of the trees as irregular shapes. If you break up the edges of these shapes, then they'll read as trees, regardless of the color you choose. In the interest of color harmony, it's best not to introduce green at this point.

DETAIL

Note how the Cadmium Orange and Cobalt Blue blend one into the other, mostly seamlessly. This is because they were mixed on the paper, not the palette. To do this requires some practice, but it's a very effective way to mix colors. The details, such as the hints of windows, are quickly washed in when the wash is almost dry.

The middle-ground building is painted in a similar fashion, using Ultramarine Blue and Quinacridone Burnt Scarlet, pigments with darker value ranges than Cobalt Blue and Cadmium Orange. This area is a slightly darker value than the background in order to bring it forward, creating the illusion of depth.

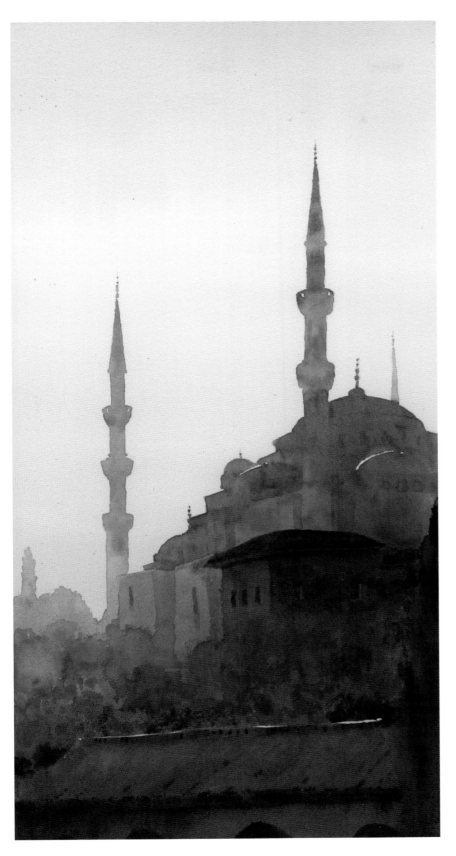

7 THE FOREGROUND

Mixing a creamy Carmine and Phthalo Green wash, paint the cypress tree on the right. If you work quickly this wash will blend into the middle-ground wash, creating a soft edge. Then mix a very thick yogurt wash and drop it into this area to make a very black area.

Since the roof is reflecting the light from the sky, the wash is slightly lighter in value, mostly Cobalt Blue and Cadmium Orange. Using the creamy Carmine and Phthalo Green mixture, add some trees behind this building and a shadow at the ridge, preserving a bit of a highlight at the top. Use some quick diagonal strokes of your dark mixture to indicate tiles, wet-into-wet.

Paint the front of the foreground building with a very thick mixture of Cobalt Blue and Cadmium Orange, varying the wash to create texture. Let this wash blend into the cypress tree, linking the shape. When this wash is almost dry, indicate the arches with your yogurt consistency dark mixture.

You can see that Cobalt Blue is the dominant color throughout the painting, followed by Cadmium Orange. By using warm and cool contrasts and by mixing pure colors on the paper, you will achieve a colorful painting without using a lot of different colors.

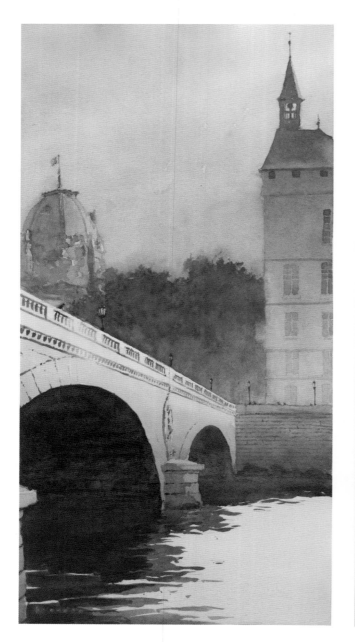

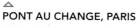

PONT AU CHANGE, PARIS
20" × 10" (51cm × 25cm)
Color strongly contributes to the mood of
this painting. The orange sunset evokes
early evening and casts a glow on the
side of the bridge.

The use of complementary colors
emphasizes certain areas: the blue tower
against the orange sky and the orange
bridge against the blue trees. These
color choices were planned in advance
during the study stage.

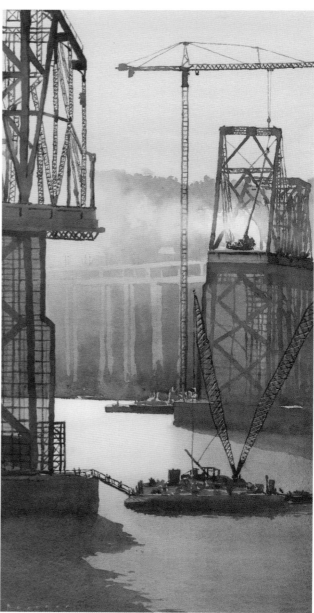

BAY BRIDGE DECONSTRUCTION
20" × 10" (51cm × 25cm)
The cool grays comprise Cobalt Blue
and/or Ultramarine Blue mixed with
their complements, Cadmium Orange,
Quinacridone Burnt Orange and
Quinacridone Burnt Scarlet. Set against
this plethora of neutral grays, the
Cadmium Red of the crane stands out.

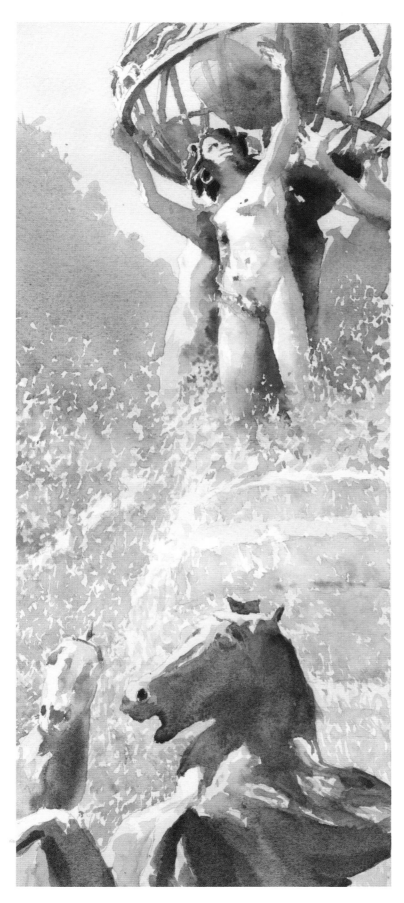

FONTAINE OBSERVATOIRE, PARIS
21" × 7" (53cm × 18cm)

Cerulean Blue dominates this painting. Cobalt Turquoise and Cobalt Blue play a supporting role. Cerulean Blue and Cobalt Turquoise are in fact the same pigment, PB 36, and behave in a similar manner. The complement to these colors, Cadmium Orange, is added in strategic places to create a glow and make the colors appear more dynamic.

You can see that it isn't necessary to use a lot of colors to make a painting work. A few colors can go a long way. Ultramarine Blue, Quinacridone Burnt Scarlet, Quinacridone Burnt Orange and a touch of Viridian are the only other colors used.

You may have noticed that I like to paint fountains. A question I'm often asked is whether or not I mask out the white dots of the water droplets. I don't. I really don't like masking agents. They are messy and create hard lines. I simply paint around the small dots.

Note also that few of the water droplets are pure white. During the underpainting stage, I paint over most of the dots to create my "almost whites," leaving only a few of these dots unpainted. This way the pure whites stand out.

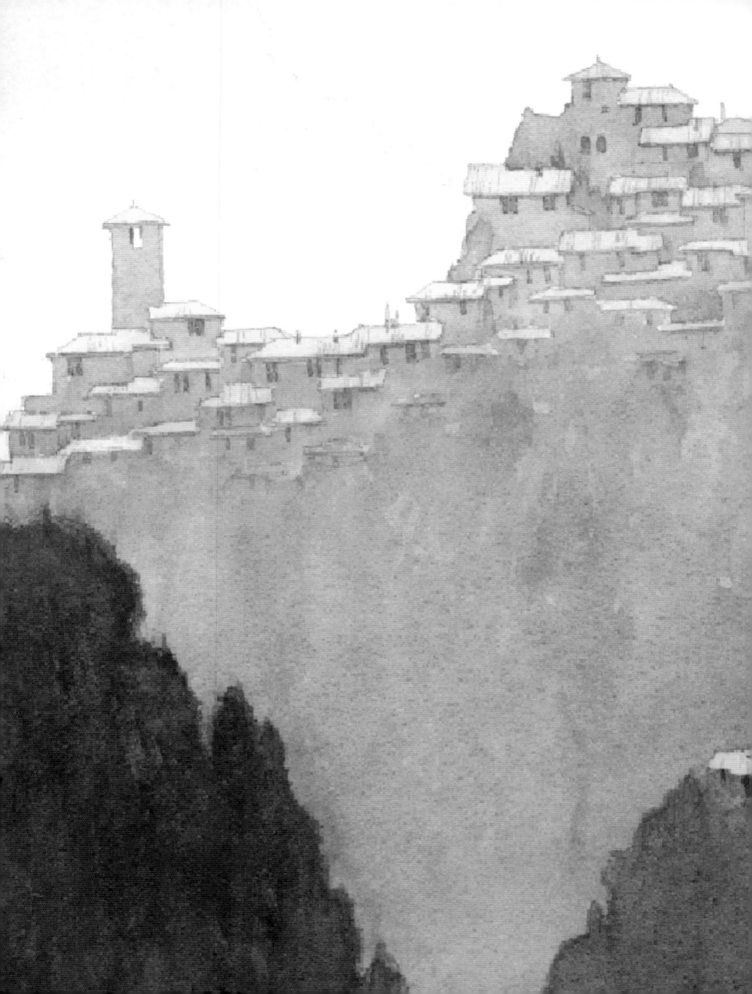

BUILDING LIGHT

◆

Capturing the ethereal qualities of light is one of the strengths of watercolor.
Watercolor literally glows when washed over paper. Much like stained glass, the light
reflects off the white paper, illuminating the pigments as it shines back through.
Architectural watercolors are a story of light. The deft manipulation of value
and color yields a compelling sense of light and sculpts three-dimensional form.
Watercolor, with its inimitable capacity to capture the luminosity of light and shadow,
is uniquely suited to build the light in your architectural art.

◁
TOSCANA
Detail

LIGHT, COLOR AND ARCHITECTURE

When painting architectural scenes, the first task is to determine the source of light and how it strikes the object. The resulting shade and shadow pattern defines the object. The light source can be direct, glancing or even from behind. Regardless, the light is always the starting point.

Color is the emotional component of light. A painting with warm light has a much different mood than cool light. Yellows and oranges produce a sense of late afternoon.

Blues and violets suggest a cool and misty milieu. Color, light and mood work together.

The combined power of light and color leads to compelling painting. Imbuing your paintings with light, infusing them with color and imparting your particular vision entrances. Working together they will entrance the viewer and yield many satisfying hours of painting in watercolor.

PORTELLO DELL'ARSENALE, VENICE
10" × 6" (25cm × 15cm)

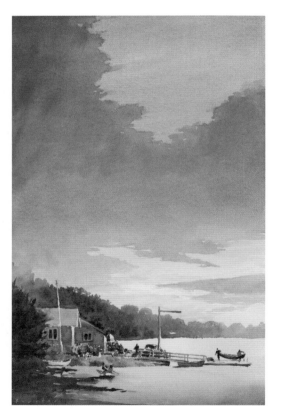

AQUATIC PARK, BERKELEY
18" × 11" (46cm × 28cm)

Note the quality of light conveyed in each of these paintings. The Venice painting has a strong sense of sunlight, while the Berkeley painting is more subdued. In both paintings the source of the light comes from the right, yet the way the light is handled is very different.

The palette of pigments is nearly identical in each painting, yet the mood is not. In the Venice painting, warm colors heighten the feeling of a sun-dappled day, while cool tones denote a chilly day in the Berkeley painting. Manipulating light and color evokes a range of moods.

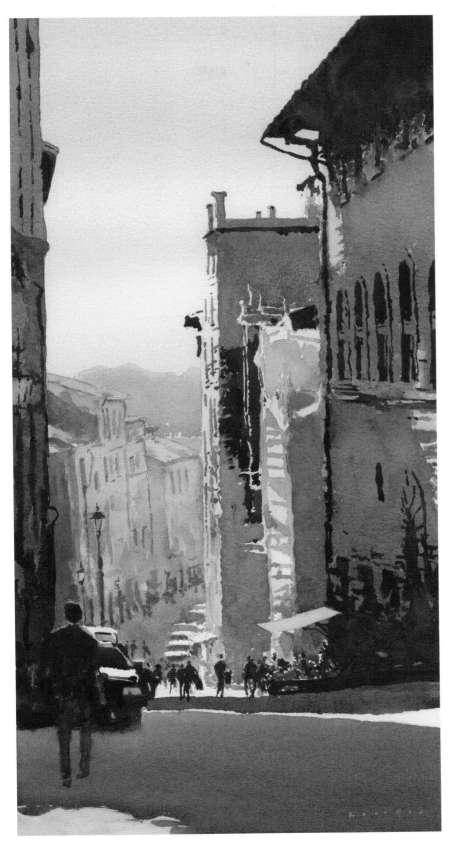

AREZZO, ITALY
20" × 10" (51cm × 25cm)

In this painting both light and color play major roles. Squint in order to better decipher the value relationships. The strong focal point and well-defined foreground, middle ground and background set the stage. The various types of edges—soft, hard and in-between—add both definition and mystery. The strong pattern of light and shadow creates a sense of drama.

Yet it is the color that evokes the warmth of a late fall afternoon. The warm yellows and oranges on the sunlit side, contrasted with the complementary cool blue-violet shadows, radiate the heat of that part of the day. Minus the color the painting would mostly succeed due to its value relationships. The color, however, conjures a mood and creates a sense of atmosphere in the scene.

FINDING YOUR WAY IN WATERCOLOR

Discovering your own painting voice comes with time. In my years of teaching, I have noticed that everyone has their own individual approach to painting. Personality seems to have something to do with it. Extroverts paint boldly, shy people paint quietly, perfectionists paint detail and dreamy souls paint suggestively. This is true, of course, with many exceptions and steps in between.

It's important to be true to your spirit and to paint subjects that move you. Even though I hope you have followed and repeated the demonstrations in this book, I don't expect people to paint just like me. It is my hope that you will incorporate the concepts—particularly about light and color—in an effort to discover your own way of painting.

Through experimentation, trial and error, you will gradually develop your own style. Take chances. Don't worry if a painting is a disaster. It's only paper. As long as you learn something, it's worthwhile. Continue to try new pigments, papers and approaches. But keep in mind the power of light and color. Exploring them is a never-ending ride.

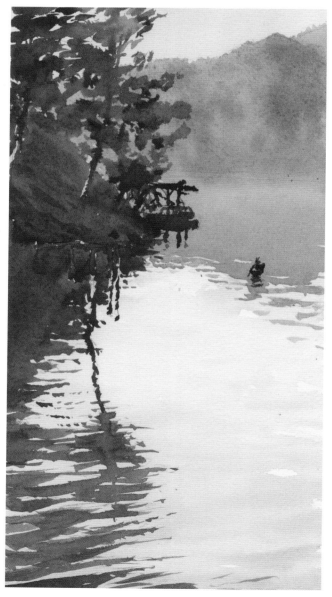

LAKE ATITLAN, GUATEMALA
10" × 6" (25cm × 15cm)
Finding your way in watercolor can be a long, lonely process. I strongly suggest finding a painting group that meets regularly. When I was learning, I joined a group that went out to paint once a month. I painted with the group for twenty-seven years. If you can't find a group, start your own. You might be surprised to find there are a lot of other solitary painters looking for company.

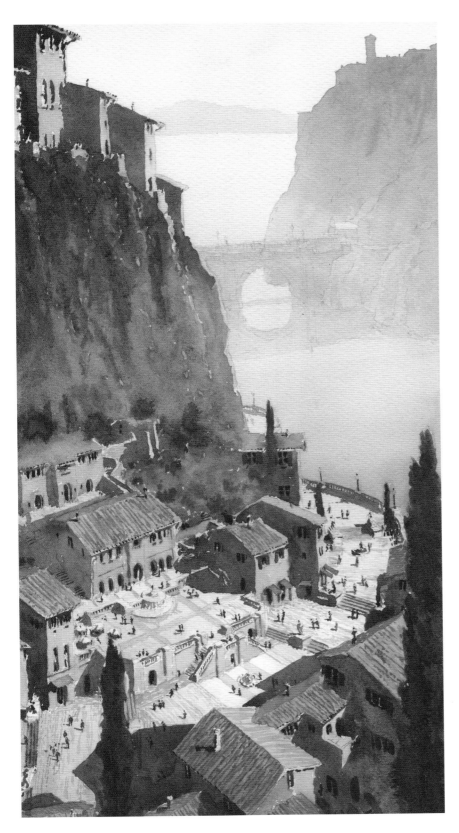

GUBBIO
25" × 10" (64cm × 25cm)

I really enjoy painting imaginary scenes. By disregarding reality you are free to use any subject or mood you can dream up. Such images begin as simple compositional thumbnails, usually no more than a couple of inches in size. If you squint, you can discern these basic shapes.

In this case, I used a simple curve to organize the painting. You can also see that I repeat curves throughout the painting. Setting up a focal point, foreground, middle ground and background completes the composition.

I use buildings and landscape elements to animate the scene and make it believable. My fondness for Italian hill town architecture is often the source for these paintings. I find that orange tile roofs and bluish landscape elements work well together. Of course, you can choose any subject matter you wish. Using your imagination is what counts.

Such imaginary paintings clear my mind, allowing me to unlock some of the creativity that is essential to painting. Doing such work has immeasurably helped me to develop my style of painting. I would encourage you to give this a try. It needn't be as involved as this painting. Freeing your imagination will help you to find your painting voice.

CONCLUSION

As every watercolorist knows, the medium can be fickle, irascible and unpredictable. Even the most experienced painters are humbled when washes go wrong. I gave up on watercolor for ten years after my first disastrous experience. For every setback, though, there are many successes. Despite its occasional orneriness, I hope you find, as I did, that there is no other medium as magical and enjoyable as watercolor.

Many resources can help you improve your painting: videos, classes and books such as this one. When I was learning, I read every book I could find. The only way to learn is through practice, diligence and studying the work of artists you admire. When you finally think you've created a masterpiece, pat yourself on the back, then grab a brush and experiment with something new.

Painting light and color is very seductive. Light, as it glances off a façade, glimmers off the water or gleams off polished marble, is always inspiring. Color, with its infinite array of hues, is always irresistible. Searching for ways to make them harmonize and tell a story is a pursuit that can last a lifetime.

▷

SANTA MARIA DELLA SALUTE, VENICE
14" × 7" (36cm × 18cm)
Seeing John Singer Sargent's painting of this Venetian landmark rekindled my desire to learn watercolor. On my first trip to Venice, I figured out his vantage point and did my own version. Each time I return to Venice I try another one. I'm not there yet. Maybe next time ...

ABOUT THE AUTHOR

Michael Reardon, a native of California, is a watercolor artist and teacher. After receiving a degree in architecture from the University California at Berkeley and a year studying architecture at a French university, he embarked on a career in architectural illustration while allocating as much time as possible to paint his own watercolors. His work has garnered many awards, including the Hugh Ferriss Memorial Prize (the highest honor in the field of architectural illustration), the Gabriel Prize from the Western European Architecture Foundation, signature membership in both the American Watercolor Society and the National Watercolor Society, and artist membership in the California Art Club. His paintings have been exhibited worldwide. He currently lives and paints in Northern California with his wife, Jill, and his cat, Princess.

△
PRISS
PRINCESS

◆

Dedication:
For Jill.

◆

To learn more about Michael and his work,
visit the following sites:

Web address: www.mreardon.com
Blog: michaelrreardon.blogspot.com
Facebook: www.facebook.com/michael.reardon.587
Contact: mreardon@mreardon.com

INDEX

a content + ecommerce company

Other fine North Light Books are available from your favorite bookstore, art supply store or online supplier. Visit our website at fwcommunity.com.

20 19 18 17 16 5 4 3 2

ISBN 13: 978-1-4403-4076-5

Edited by **Kristy Conlin**
Designed by **Elyse Schwanke**
Production coordinated by **Jennifer Bass**

DISTRIBUTED IN CANADA BY FRASER DIRECT
100 Armstrong Avenue
Georgetown, ON, Canada L7G 5S4
Tel: (905) 877-4411

DISTRIBUTED IN THE U.K. AND EUROPE BY F&W MEDIA INTERNATIONAL, LTD
Brunel House, Forde Close, Newton Abbot, TQ12 4PU, UK
Tel: (+44) 1626 323200,
Fax: (+44) 1626 323319

Email: enquiries@fwmedia.com
DISTRIBUTED IN AUSTRALIA BY CAPRICORN LINK
P.O. Box 704, S. Windsor NSW, 2756 Australia
Tel: (02) 4560-1600; Fax: (02) 4577 5288
Email: books@capricornlink.com.au

△
LE SQUARE JEAN XXIII, PARIS
18" × 11" (46cm × 28cm)

◆———————————◆

Acknowledgments:
Many thanks go to my editor, Kristy Conlin, and North Light Books for all of their help and inspiration. This book would never have come to fruition without them.

◆———————————◆

METRIC CONVERSION CHART

To convert	to	multiply by
Inches	Centimeters	2.54
Centimeters	Inches	0.4
Feet	Centimeters	30.5
Centimeters	Feet	0.03
Yards	Meters	0.9
Meters	Yards	1.1